Pat —
Happy Birthday!
 11/30/2011
Love,
Carol and Jay

IMAGES
of America

HIGHLANDTOWN
REVISITED

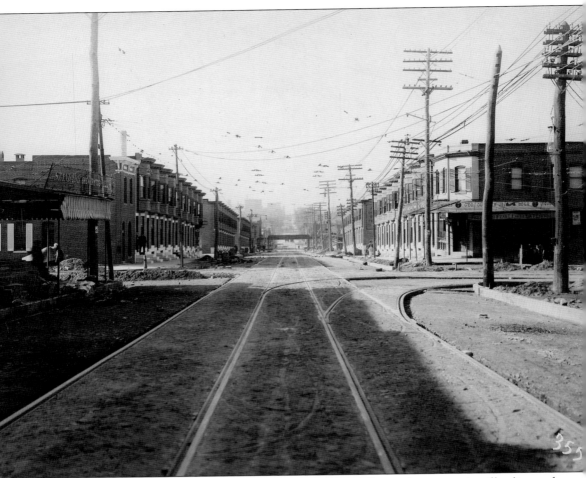

Looking west from Eastern Avenue and Fifteenth (Oldham) Street, the avenue is still a dirt road in this image from the fall of 1915, however, paving blocks, shown to the left, are about to be installed. George Gunther's café at right is advertising a free crab feast every Saturday evening, and in the distance, the fly tower of the new Grand Theater is visible just left of the center of the photograph. (Courtesy of Maryland Rail Heritage Library of the Baltimore Streetcar Museum, Inc., Baltimore Chapter of the National Railway Historical Society, Inc.)

ON THE COVER: In the turmoil that was December 1941 and the years that would immediately follow, the carefree faces of . School's first class of kindergarten students reflect the timeless innocence of youth. (Courtesy of Florence Sdanowich.)

IMAGES
of America

HIGHLANDTOWN
REVISITED

Gary Helton

ARCADIA
PUBLISHING

Published by Arcadia Publishing
Charleston, South Carolina

Printed in the United States of America

Library of Congress Control Number: 2010940478

For all general information, please contact Arcadia Publishing:
Telephone 843-853-2070
Fax 843-853-0044
E-mail sales@arcadiapublishing.com
For customer service and orders:
Toll-Free 1-888-313-2665

Visit us on the Internet at www.arcadiapublishing.com

*This book is dedicated to the memory of my friend Bill
Bates (1956–2010), a gentleman and a gentle man, and
the writer who introduced me to Arcadia Publishing.*

CONTENTS

Acknowledgments

I would like to thank the following people and organizations for contributing photographs and information used in this publication: Tiffany Bock, Jim Charvat Jr., Mary Moscato Chaikin, Tom Moscato, Bud Hash, Stanley Sdanowich, Charlene Umberger, Nancy Van Keuren, Margie Policastri, John von Paris, Vincent De Paul (Zannino), John Meisenhalder, Cecilia Trentowski, Don Ulsch, Barbara Cosner Hall, Debra Amend-Libercci, Shelley Sealover, Ed Dobbins, Jean Jomidad, Tom Trentowski, Jerry Kelly, the Creative Alliance at the Patterson, Jim Baker, and Joe LaPaglia. I also want to thank Jennifer Bodine and Richard Orban, of AAubreyBodine.com for allowing me to include in this volume nine of the timeless images by master photographer A. Aubrey Bodine.

My appreciation is also extended to Glen English, Pastor Mark Parker, Anthony Benvenga, Dennis O'Hara, Tony Hall, John Dixon, Hilary Figinski, Tom Charvat, and Canton Kitchens for providing information, support, and identifications.

Special thanks go to Felicia Zannino-Baker and Florence Sdanowich for all their contributions and support. Highlandtown is definitely a better place because of you two special ladies.

And finally, a sincere thank you goes to everyone who purchased my 2006 publication, Images of America: *Highlandtown*. It was your support, feedback, and encouragement that prompted the follow-up book you now hold in your hands. I hope you will enjoy it just as much, if not more, than the first one.

—Gary Helton
December 22, 2010

INTRODUCTION

When Images of America: *Highlandtown* was released in 2006, the public response was nothing short of overwhelming. And considering the fact that Arcadia Publishing was not exactly enthralled with the project in the beginning, I took a great deal of satisfaction from the book's reception. After all, several people at Arcadia said Highlandtown was just a gritty, old neighborhood in East Baltimore whose best days were behind it. And on the surface, there was little to dispute that assessment. However, in response, I argued Highlandtown is a true community in every sense of the word. According to Dictionary.com, a community is "a social, religious, occupational, or other group sharing common characteristics or interests and perceived or perceiving itself as distinct in some respect from the larger society within which it exists." Now if that did not sum up Highlandtown—its spirit and character—then I did not know what did. I went on to assure my editor at the time that Highlandtown was also a state of mind, much like the following expression: you can take the boy out of the country, but you cannot take the country out of the boy. As cliché as that is, it is the same with Highlandtown. And while the children, grandchildren, and great-grandchildren of old-time Highlandtown have scattered like seeds in the wind, the umbilical cord connecting them to their Highlandtown roots remains intact. Highlandtowners, I concluded, embrace their heritage rather than run from it. Oh, some may run from it for a while, but eventually, most miss it and return, either physically or through memories that have grown fonder over time. In the end, Arcadia accepted my arguments. Maybe they just got tired of hearing me. In any case, they agreed to let the project proceed. Of the four books I have produced in the Images of America series, the one on Highlandtown remains the most popular by far.

So, just what is this *spirit* of Highlandtown that I referred to, and why, for a community that has long been the butt of jokes, do its residents and their descendents embrace it so? It is rooted, I believe, in the strong ethnocentric family values brought from Germany, Poland, Italy, Wales, Russia, Greece, Ireland, and Bohemia. Most often at the core of these cultures was the church. When laborers from these lands arrived in Baltimore, they found work in the factories and industries that dotted the Canton and Fells Point waterfront. As employers grew, so did the labor force and the need for more housing. Inching ever northward from the water's edge, Highlandtown developed like a growing child. Over time, ethnic pockets emerged along various city blocks. From this rock-solid foundation emerged a community. Independent and stubborn, members of the community watched out for each other's kids, sponsored new immigrants and helped them find work, and embraced America and what it meant to be an American while holding on firmly and proudly to their ethnic heritage. And they enjoyed referring to the rest of Baltimore as "West Highlandtown." It was not the perfect community—never has been, never will be—but it was a real community with real, blue-collar people not all spit and polish, just genuine. In our modern times—when antisocial behavior is rewarded with book deals and reality television shows, profanity-laced music is glorified, and overindulged celebrities are blindly worshipped like gods—the idea of genuine people in a genuine community is more than a little refreshing. That, I believe, is the spirit of Highlandtown: to be genuine and not surrender, belittle, or lower your values and standards just because they are no longer cool. Shakespeare said it best, "To thine own self be true."

By the mid-20th century, Highlandtown was, by most people's standards, enjoying its golden age. World War II was over. Jobs at Bethlehem Steel, Esso, General Motors, Esskay, National Beer, and elsewhere were abundant. The retail district on and around Eastern Avenue was thriving. Churches were more often than not filled to capacity, and inflation was a word used in conjunction with balloons or automobile tires, not the economy. Some families owned cars. Others relied on the semi-reliable service provided by the Baltimore Transit Company. Business at the neighborhood grocer, butcher, and baker thrived. Bars and barbers made out perfectly well, too. When needs exceeded what could be found down the block, we trekked to Eastern Avenue to Irvin's and Epstein's Department Store, Kresge's or F.W. Woolworth's, Louis J. Smith Sporting Goods, Yeager's Music, Wieland's Furniture, and the Arundel. What other Baltimore community could boast two Read's Drugstores and two White Coffee Pot restaurants located all within a few blocks of each other? There was every variety of sport in Patterson Park: the church duckpin leagues, social and fraternal organizations for adults, and the Boys' Club for kids. The luckiest children had wading pools and bicycles or got pony rides when the man came by. There was little or no air-conditioning, except in the Grand and Patterson Theaters and perhaps in a couple of stores on the Avenue. So on summer evenings, we sat on the front steps to talk, play, and otherwise enjoy the cool of evening and the fellowship it brought. There were endless games of curb ball, hopscotch, tag, and jump rope, with the old folks warning us whenever a car, or "a machine," approached. They also did not hesitate to inform our parents when we were up to no good or uttered a curse word. It was a simple, magical time—which we appreciate more and more with each passing day—when everyone and everything depended upon each other, and we knew it. That was the golden age in Highlandtown. There was something normal, secure, and comforting about the whole thing.

Highlandtown's golden age did not come to a screeching halt. It gradually eroded over time as suburbs grew, shopping centers appeared, and car ownership became more common. Every action has an equal and opposite reaction. The decline progressed slowly, beginning in the 1950s. By the 1990s, it appeared to be complete. Gone were most of the long-familiar employers and retailers and, with them, most of the corner establishments. The once beloved Grand Theater sat abandoned. Haussner's Restaurant was closed. Yeager's was gone, and even the Patterson Theater threw in the towel. Church attendance dropped off dramatically, and several Catholic schools closed. Property values declined, and crime rose. Newspaper accounts of prostitution in and around Patterson Park made it a place to fear and avoid at night. And the new generation of immigrants, Latinos, was generally greeted with disdain and suspicion. Highlandtown was at a crossroads. Its spirit was gone, or so it seemed.

As the second decade of the 21st century dawns, Highlandtown finds itself the beneficiary of the resurgence of Canton, Fells Point, and other nearby neighborhoods. A new generation—with new ideas and energy—has arrived, and members of this new era are investing their time, talents, and money into the community. Homes are being rehabilitated and restored. Patterson Park is once again a safe hub of social and leisure activity, ethnic fairs, and sports. In less than 20 years, new residents have swarmed into the neighborhood like bees—their positive energy contagious— and this new blood, in concert with the remnants of the old values and traditions, has forced Highlandtown out of its lethargy. Some blocks on various streets still resist the upswing, but it is clearly just a matter of time before this new spirit overwhelms them, too.

One

BE IT EVER SO HUMBLE

"There's no place like home" are lyrics from the 1823 song "Home Sweet Home." Highlandtown's homes do not go back quite that far but are, in fact, humble. There are no sprawling estates or Georgian mansions here—just blocks and blocks of row houses with only minor interior and exterior variations. The average home measures 13 to 14 feet wide and has around 1,000 square feet of living space, not including the usually concrete postage-stamp backyard. Many have those famous Baltimore marble steps out front, while others have stairs made of brick or wood. The brick facades of many homes are covered with formstone, a faux stone material, or painted over, however, the original red, tan, or brown brickwork is still visible on some homes. In the beginning, they were heated by steam. Kitchens were in basements, and the "facilities" were in the backyard. The Highlandtown homes of today began to emerge around 1905. It is truly mind-boggling to realize these same homes—some of which fetch $300,000 or more today—originally cost, on average, $1,000 to $2,000 a century ago. It is equally difficult to understand how families, some with 10 or more children, flourished in the small confines of Highlandtown's row houses while maintaining some degree of sanity and decorum. Those are things to reflect on during this chapter, which highlights several typical Highlandtown homes, inside and out.

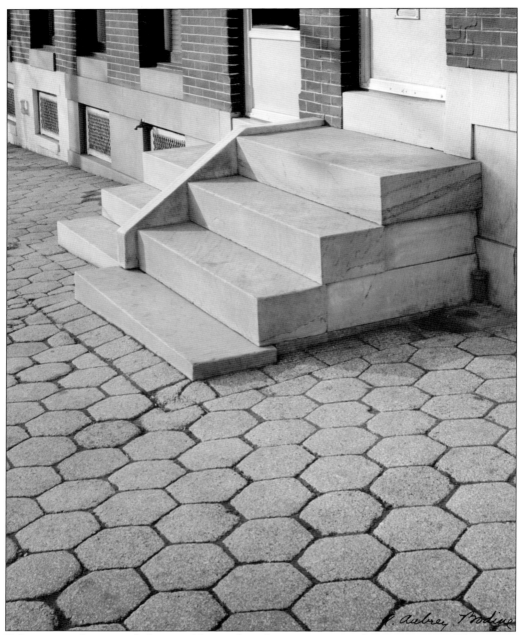

Baltimore row houses and white marble steps have been synonymous for over a century. This image, taken in 1963, also features the unique inlaid-block sidewalk of Patterson Park Avenue. (Photograph by A. Aubrey Bodine, copyright Jennifer B. Bodine; courtesy of AAubreyBodine.com.)

The 600 block of Luzerne Avenue, with Patterson Park and St. Elizabeth of Hungary Church in the background, makes for a fine representation of the residences of Highlandtown. Constructed in the early 20th century, these signature Baltimore row houses average a little less than 1,000 square feet of living space. (Courtesy of Tiffany Bock.)

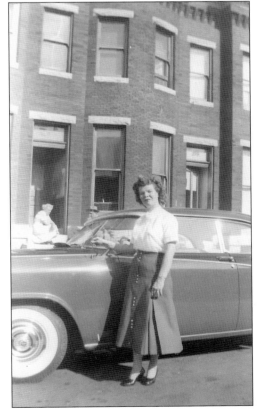

Frances Smith is seen posing with the family car in this image from the 1950s. In the background are row houses, with every other home featuring a bowed front wall design, in the 200 block of North Luzerne Avenue. (Courtesy of Jim Charvat Jr.)

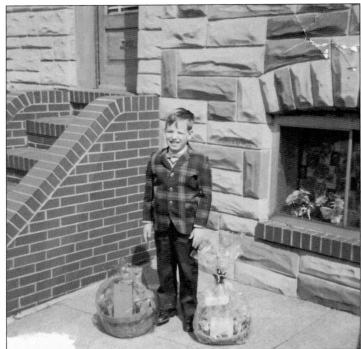

Formstone was a very popular faux stone affixed to the exterior of many a Highlandtown row house. The application of formstone was often done to compensate for defective bricks that allowed rain to seep through to interior walls. Joey Olencz is seen in this snapshot from Easter Sunday 1967 in front of 503 South Bouldin Street. (Courtesy of Nancy Van Keuren.)

Formstone appears here, attached to the fronts of these homes in the 100 block of North Luzerne Avenue. It was originally created to give a seamless appearance to rural homes with multiple additions, such as farmhouses. Today, the number of formstone houses is dwindling, as new residents of Highlandtown are restoring the homes to their original appearances. (Courtesy of Tiffany Bock.)

Oversized chairs, doilies, and flowered wallpaper were common in early Highlandtown homes. Here is the author's mother, Elizabeth Marshall Helton (1930–1999), at 721 South Grundy Street in March 1951, and while the family moved in 1953, the heavy, deep blue furniture stayed with them for another decade. (Author's.)

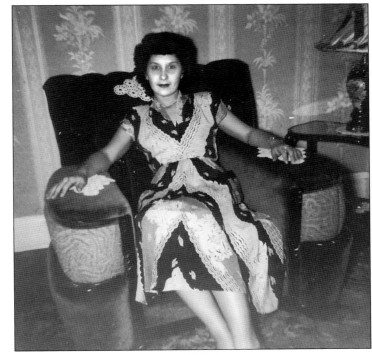

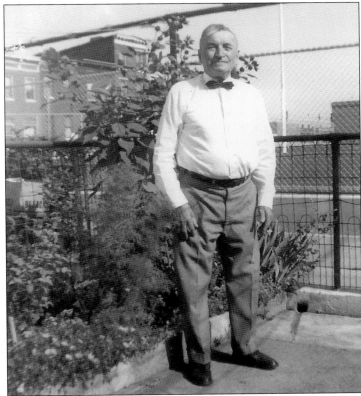

Highlandtown backyards are tiny by just about anyone's standards. Still, for many owners, they have been as much a source of pride as the home's interior. This late-1950s shot features Joseph Olencz with his flower garden in the rear of 3130 Dillon Street. (Courtesy of Nancy Van Keuren.)

Here are Donna Krupa Korcyzkowski and Helen Krupa around 1965 under the clothesline in the yard of 124 North Luzerne Avenue. There was a certain Highlandtown etiquette about hanging one's laundry outside to dry. Sheets, towels, tablecloths, and similar large items went on the outer lines to obscure a neighbor's view of undergarments and other unmentionables, which hung from an inner line. (Courtesy of Tiffany Bock.)

Santa Claus was his usual generous self in 1951. When the child at this South Grundy Street home awoke on Christmas morning, she found dolls, Lionel trains, and a shiny new tricycle beneath the tree. A steam radiator is partially visible at right. Today, one would be hard-pressed to find a home in Highlandtown that is still heated by steam. (Author's.)

From left to right, Mr. Zinc, John Bennett, and Will Bennett take a breather on a deck built atop a backyard enclosure. It was here that the Bennetts raised pigeons at 1006 South Highland Avenue. The photograph was snapped on March 29, 1936. (Courtesy of John Meisenhalder.)

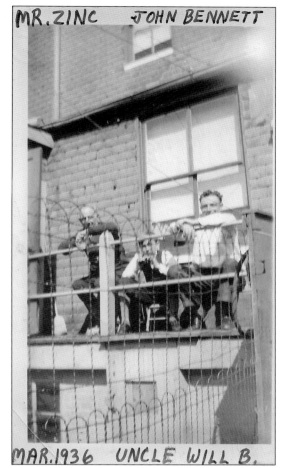

MR. ZINC JOHN BENNETT

MAR. 1936 UNCLE WILL B.

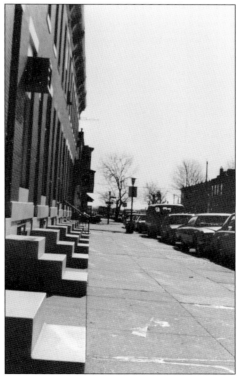

This photograph, taken during the 1970s, shows the exterior of row houses on Potomac Street. In the Monkee's song "Pleasant Valley Sunday," the lyrics include the following: "Rows of houses that are all the same, and no one seems to care." Apathy, as described in the song, is something Highlandtowners have never been guilty of. (Courtesy of Debra Amend-Libercci.)

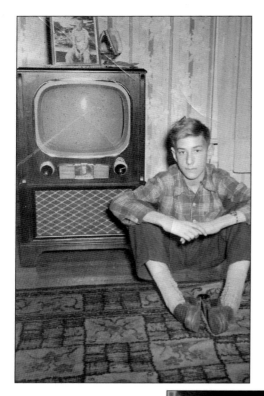

What photo album does not include a picture of the family's first television set? The Ulsch family of South Conkling Street took this snapshot of their brand-new Zenith television, and son Donald sitting alongside of it, in 1951. Like most Baltimore residents back then, Highlandtowners were limited to just three channels, 2, 11, and 13, a concept today's young people find incomprehensible. (Courtesy of Don Ulsch.)

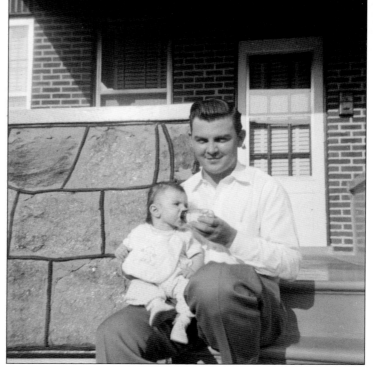

Here is the author's father, Orville Helton (1924–2005), feeding his infant daughter Sharon on the front steps of 721 South Grundy Street in 1951. The distinct pattern of the stone front porch is unchanged today. The family rented this home until 1953. (Author's.)

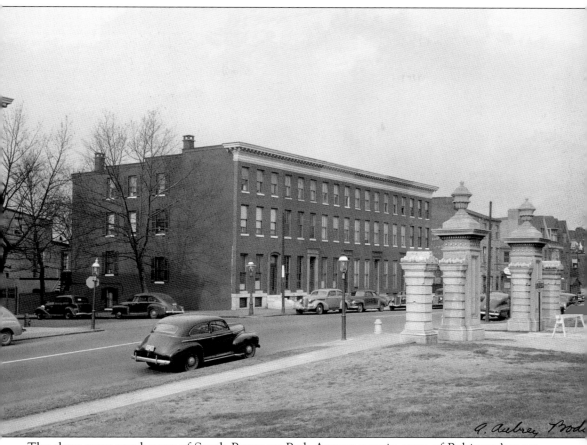

The three-story row houses of South Patterson Park Avenue remain some of Baltimore's most beautiful and expensive in this pocket of Highlandtown known as Butcher's Hill. Looking from the intersection of Patterson Park Avenue and Lombard Street, this view of the marble entrance to Patterson Park on the right is from 1949. (Photograph by A. Aubrey Bodine, copyright Jennifer B. Bodine; courtesy of AAubreyBodine.com.)

It is April 1963, and Joe Adams is all smiles as he poses with grandson Joe Nowicki in front of Adams's home in the 800 block of South Robinson Street. For years, residents routinely scrubbed clean their white marble steps on a weekly basis, a tradition that has regrettably, for the most part, died out. (Courtesy of Don Ulsch.)

Perfect Little Palaces

$1350.00 100 block North Ellwood Avenue

Between Fairmount Ave. and Fayette Street. Two Story, Six Rooms, Bath, Gas Ranges, Stationery Washtubs, Sewer Connections.

═══ ALL MODERN CONVENIENCES ═══

— ALSO —

$775.00 800 block South Lakewood Avenue

This advertisement appeared in an event program at St. Elizabeth of Hungary Church in 1905. Suffice it to say, property values have increased just a bit since then. (Courtesy of Jean Jomidad.)

Two

HIGHLANDTOWN AT WORK

Many of the original residents of Snake Hill, later known as Highlandtown, brought certain trades, training, and skills with them from Europe. Others just came with a strong back and no fear of dirt and sweat. Most importantly, they possessed a strong work ethic and the desire to succeed. There was no government unemployment insurance and little in the form of social safety nets. Failure in the arena of employment was not an option. Early manufacturing jobs and workplace environments often ranged from primitive and challenging, at the least, to downright dangerous and deadly. There were no provisions for sick time or disability leave. So an employee either stayed safe, healthy, and on the job or there was no payday. Most of the jobs were with Bethlehem Steel at its massive Sparrows Point plant and shipyard or the Key Highway dry dock in Baltimore. Still, others cranked out Chevrolets at the huge General Motors plant in Dundalk. The breweries—National and Gunther, which later became Hamm's and, ultimately, F. & M. Schaefer Brewing Company—were big employers, too. Standard Oil had a sprawling Esso refinery between O'Donnell Street and the Patapsco River. Western Electric manufactured telephones from a complex on Broening Highway at Colgate Creek, the former site of Riverview amusement park. I.C. Isaac's made clothing. Camp (later Fort) Holabird had a large civilian workforce. And Crown Cork & Seal operated a major plant, first on Eastern Avenue and later on O'Donnell Street. There was also plenty of work at the port and with the railroads. Supporting these big employers were the retailers and small mom-and-pop businesses, like restaurants and bars. Together, they were the economic fuel that powered the engine of Highlandtown.

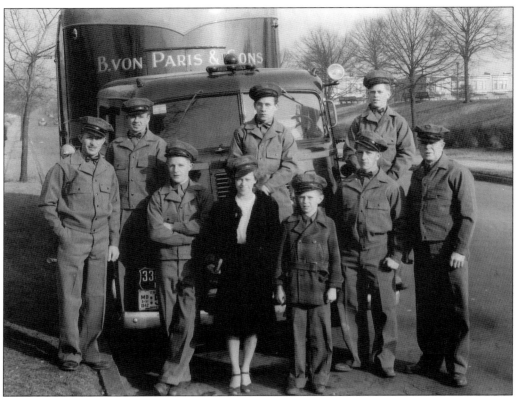

Taken in 1941 on Linwood Avenue alongside Patterson Park, members of the von Paris family pose in new company uniforms with their first tractor trailer. Von Paris Enterprises, as the firm is now called, began as a general hauling business in 1892 at 3325 Foster Avenue with a team of horses, two dump carts, and a double-team wagon. Family patriarch Bonaventure von Paris Sr. is at the far right. (Courtesy of John von Paris.)

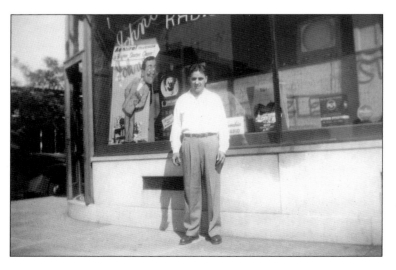

John Moscato is shown standing in front of his radio and television shop at Highland Avenue and Gough Street. Moscato learned how to service radios through a correspondence school while employed with Bethlehem Steel at Sparrows Point. This photograph is from the 1950s. (Courtesy of Mary Moscato Chaikin.)

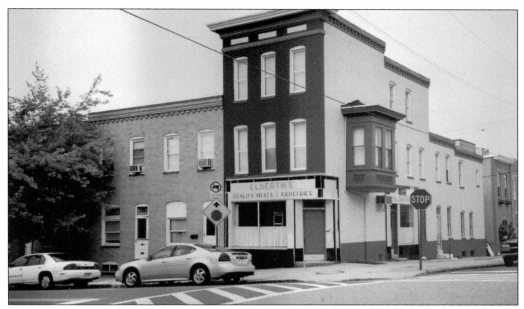

In the early days of Highlandtown, it seems there was a butcher, baker, bartender, or barber on every corner. Sadly, most have now disappeared. Elberth's, with its distinctive lime-green facade, sits vacant at Clinton Street and Foster Avenue as this book goes to press in 2011. The building is being rehabbed for a new use. (Courtesy of Tiffany Bock.)

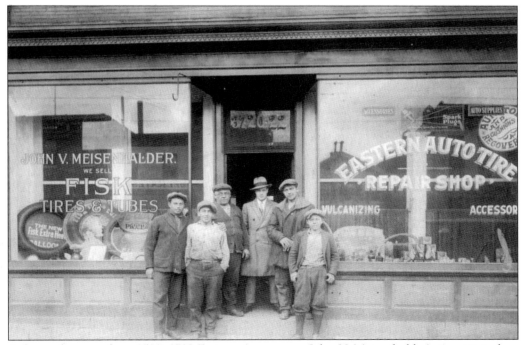

A former harness shop, 3720–3722 Eastern Avenue was John V. Meisenhalder's tire repair shop when this photograph was taken in 1927. The owner is the third man from the left. Real estate records indicate the building was constructed in 1910. (Courtesy of John Meisenhalder.)

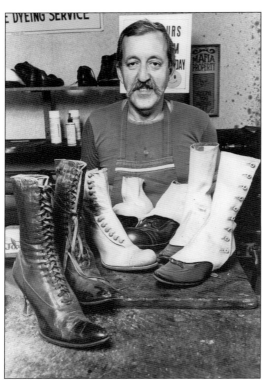

Joe LaPaglia was, for 40 years, known simply as "Joe the Shoemaker." His shop at Kenwood and Fairmount Avenues featured a window display of antique footwear, which he posed with when a photographer paid him a visit late in his career. (Courtesy of Joe LaPaglia.)

The Baltimore City Fire Department was organized in 1858. Engine House No. 41, located at 520 South Conkling Street, is one of its busiest stations. Highlandtown's firehouse was constructed in 1920, according to city real estate records. (Author's.)

The Von Paris company occupied this corner building at Highland Avenue and Bank Street for many years. At the time of this photograph, the words "Highland Storage Company" were still faintly visible at the top of the redbrick wall facing south. Von Paris Enterprises is now headquartered in Savage, Maryland, and dental offices can be found at this site today. (Author's.)

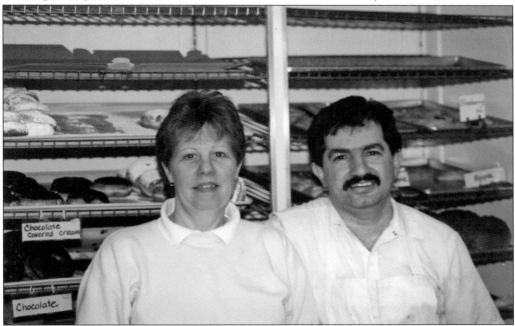

George and Carol Pegg Stavropolis were the last owners of the iconic Linwood Bakery located at Linwood Avenue and Fayette Street. For a brief period, they operated a second location in Bel Air, Maryland. After selling, the couple went their separate ways. In 2006, George became the pastry chef at the Bellagio Hotel and Casino in Las Vegas. (Author's.)

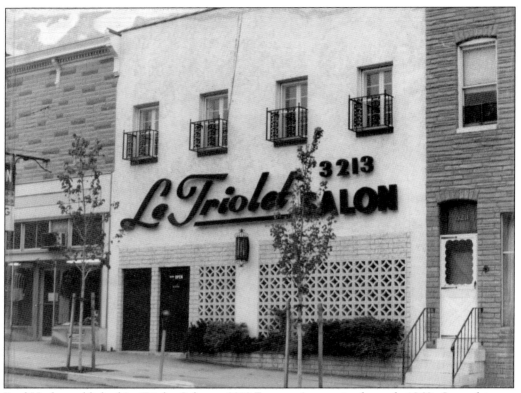

Fred Hash established Le Triolet Salon at 3213 Eastern Avenue in the early 1960s. Later, his son Bud operated it. An accomplished ballroom dancer, Bud once appeared in an episode of the television series *The West Wing* playing, as one might guess, a dancer. (Courtesy of Bud Hash.)

A popular Highlandtown destination was the Grand Theater. One of the doormen, remembered only as Mr. George, is seen in this 1974 photograph with fellow employee Lorraine Metallo. Patrons entering the Grand walked down a small set of stairs, past the doorman's position (seen here), into the dark lobby, past the candy case, and into an even darker auditorium. (Courtesy of Barbara Cosner Hall.)

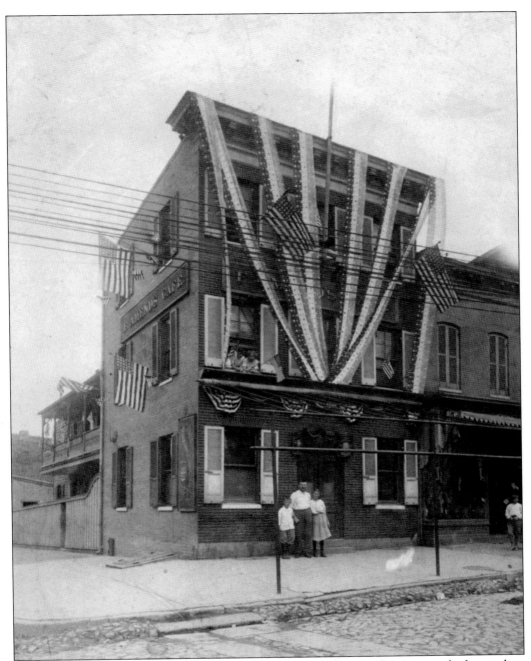

F. Amend's Café was situated on the corner of Eastern and Highland Avenues, which was then called First Street. The proprietor of the café, Franz Amend (center), is shown flanked by his son Fred and Franz's sister Helen. Franz was known for serving locally brewed Bauernschmidt's beer to thirsty customers. This 1915 photograph shows the café all decked out in celebration of the Fourth of July. (Courtesy of Debra Amend-Libercci.)

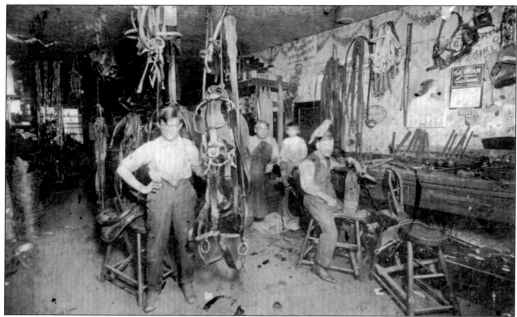

This photograph, believed to be from March 1913, shows the interior of John V. Meisenhalder's harness shop at 3720–3722 Eastern Avenue. Meisenhalder is second from the left, next to his son Fred. The men at the left and right—yes, there is a bird on someone's head—are unidentified. (Courtesy of John Meisenhalder.)

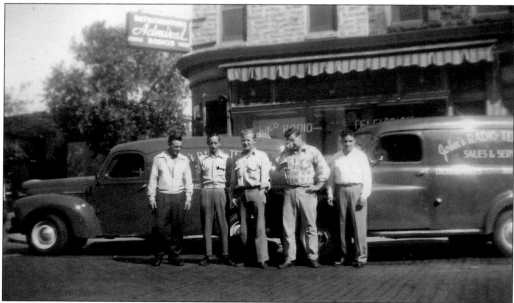

John's Radio & Television was at 301–303 South Highland Avenue. Initially, John Moscato opened the shop in 1946 to sell and service radios. It became Baltimore's first television shop a year later. John is at the far right, next to his brother-in-law Ted Fratta. Another brother-in-law, Louis Fratta, is at the far left. The other men are unidentified in this early-1950s photograph. (Courtesy of Mary Moscato Chaikin.)

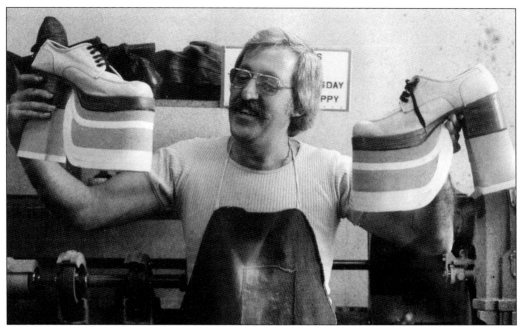

When the rock group Kiss came to Baltimore, the band members' outrageous platform shoes were in need of repair. Leader Gene Simmons supposedly opened the *Yellow Pages* to the shoe repair section and then threw a knife at the book; it landed on the listing for Joe LaPaglia's Highlandtown shop. This photograph is a testament to the expression "every picture tells a story." (Courtesy of Joe LaPaglia.)

From this iconic structure at O'Donnell and Conkling Streets came the products of the National Brewing Company. From 1885 until National was sold to Canadian brewer Carling in 1978, suds flowed from the redbrick building atop a corner that was commonly known as Brewer's Hill. (Courtesy of Tiffany Bock.)

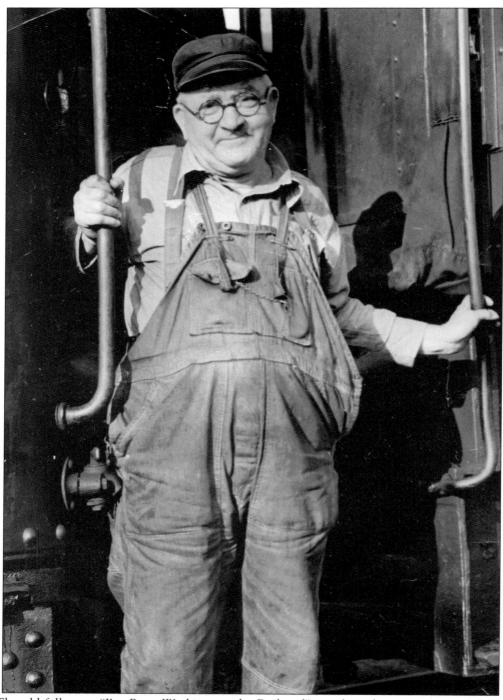

The old folk song "I've Been Working on the Railroad" may have been written with John Kress in mind. A resident of 3124 East Baltimore Street, Kress worked as an engineer for the old Pennsylvania Railroad for more than half a century—from 1887 until 1938. (Courtesy of Debra Amend-Libercci.)

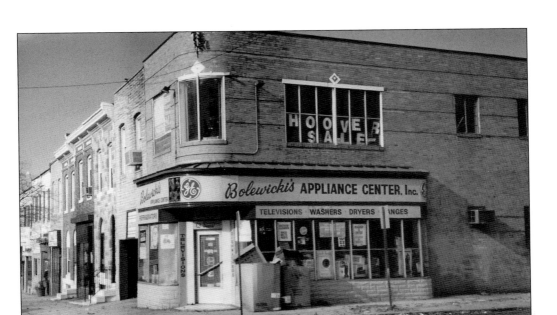

Bolewicki's Appliance Center has been a fixture at the corner of Eastern Avenue and Bouldin Street since 1946. It was established and operated by Joseph Bolewicki Sr., his daughter Irene, and his son Joe Jr. When Joseph M. Bolewicki Jr. died at age 84 in July 2010, his obituary referred to him as the "last of the old-school Highlandtown retail giants." (Courtesy of Tiffany Bock.)

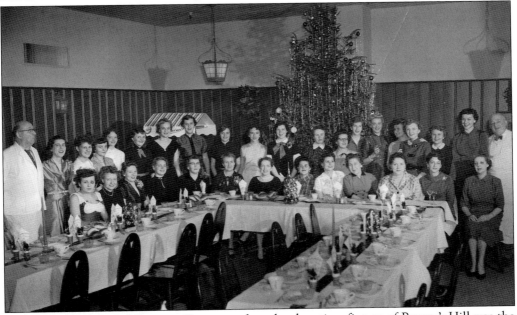

In addition to National Brewing Company, the other longtime fixture of Brewer's Hill was the George Gunther Brewery directly across O'Donnell Street. Originally spelled Guenther, the brewery was purchased by Hamm's in 1959, which sold out to the F. & M. Schaefer Brewing Company of Brooklyn, New York, three years later. This image from 1954 or 1955 is of a Christmas party for Gunther's office staff. (Courtesy of Florence Sdanowich.)

Joseph N. and Maria G. Zannino established the Zannino Funeral Home at 263 South Conkling Street. Situated in an area of Highlandtown that has long had a large Italian American population, this highly respected establishment remains family owned and operated. (Courtesy of Felicia Zannino-Baker.)

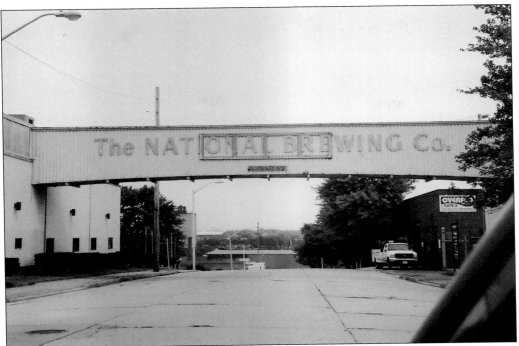

The old National beer plant has been converted to a multiuse building called the "Natty Boh Towers" and housing offices and apartments. On the Dillon Street side, evidence of the facility's past remains, as seen in this recent photograph. (Courtesy of Tiffany Bock.)

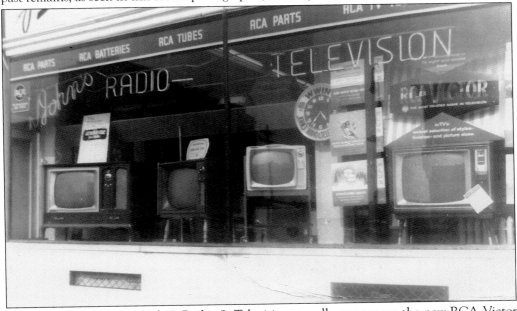

A sign in the window of John's Radio & Television proudly announces the new RCA Victor televisions for 1961. As fate would have it, the shop would eventually serve as a location for the HBO television series *The Wire*, a crime drama set in Baltimore and filmed from 2002 to 2008. (Courtesy of Mary Moscato Chaikin.)

Harry Placide converted a portion of his home, 423 North Glover Street, to a workshop where he built and upholstered furniture for a living. He earned a reputation in the community for his high-quality craftsmanship. (Courtesy of Debra Amend-Libercci.)

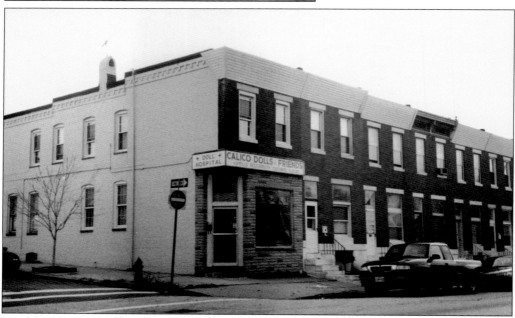

Specialty shops like this one have long been common throughout Highlandtown. Calico Dolls & Friends, located at 2919 Eastern Avenue, called itself a "doll hospital." Here, customers could bring antique dolls for repairs or, perhaps, a new set of clothing. (Courtesy of Tiffany Bock.)

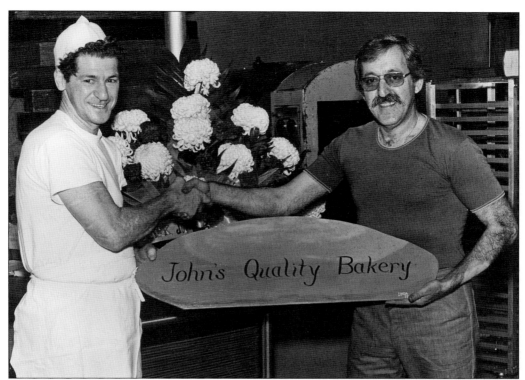

In this 1977 photograph, Joe the Shoemaker presents "John the Baker" with a custom sign for his bakery, John's Quality Bakery, at 35 North Kenwood Avenue. Made by Joe LaPaglia's daughter Linda, the sign resembled one of John Mulvaney's famous loaves of bread. Mulvaney's former employees remember him fondly. (Courtesy of Joe LaPaglia.)

In this shot from the early 1960s, a small boy can be seen entering the shop of Joe the Shoemaker, which was located at Kenwood and Fairmount Avenues. Joe was popular with area youngsters, giving them used heels as a substitute to chalk for drawing hopscotch courts on the alley or sidewalk. (Courtesy of Joe LaPaglia.)

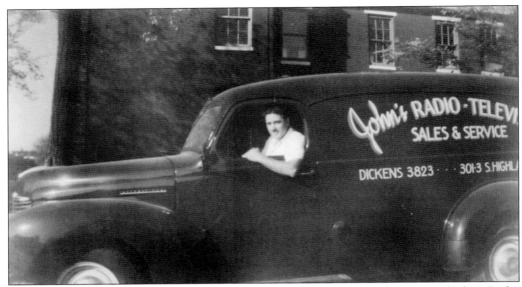

Behind the wheel of this International panel truck is John Moscato, the owner of John's Radio & Television on Highland Avenue at Gough Street. Moscato worked for Bethlehem Steel at Sparrows Point for 18 years before establishing his shop in 1946. This photograph is from the early 1950s. (Courtesy of Mary Moscato Chaikin.)

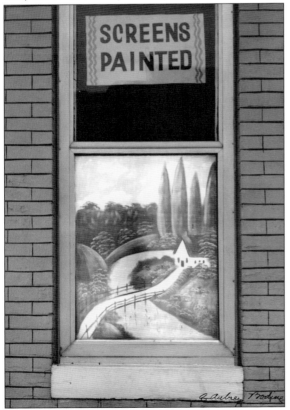

The unique art of screen painting reportedly began in the early 20th century and is credited to Czech immigrant Walter Oktavec. Today, as an organization, the Baltimore Painted Screen Society conducts classes and workshops on the art. While not as popular as they once were, painted screens can still be found throughout Highlandtown. (Photograph by A. Aubrey Bodine, copyright Jennifer B. Bodine; courtesy of AAubreyBodine.com.)

Three

HIGHLANDTOWN AT PLAY

Where does one begin to explain playtime in Highlandtown? The oasis that is Patterson Park dates back to 1667 and a 50-acre tract called Parker's Haven. This is most certainly the focal point of any summary about recreation in Highlandtown. Walking and biking paths, the observatory (also known as the Pagoda), ball fields, an ice rink, playgrounds, lake, swimming pool, and tennis courts survive today. The park remains a popular venue for concerts and ethnic fairs, league sports, bird-watching, squirrel feeding, bike riding, jogging, and leisurely walks. More than 1,500 trees from over 50 different species cover its 260-plus acres, providing much needed shade from the heat and humidity of Baltimore summers. In the past, it offered a conservatory, an ice cream "saloon," and a music pavilion with its very own band. Beyond the boundaries of Patterson Park are the school yards and playgrounds, taverns, alleys, and streets, which all qualify as a site for recreation of sorts. In the past, duckpin bowling was hugely popular, with establishments on Eastern Avenue and Eaton, Fleet, and Conkling Streets. Even churches had bowling lanes in their basements, gyms, and elsewhere. Today, while just one facility—Patterson Bowling Center—remains, it prides itself in being the oldest duckpin house in America (1927). Vaudeville and movie theaters once dotted Highlandtown. The Grand Theater, which opened as a live entertainment venue in 1914, and the Patterson Theater were the last to exist. However, at one time, moviegoers had their choice in theaters: the Eagle at 3610 Eastern Avenue, Linwood at 902 South Linwood Avenue, Highland at 225 South Highland Avenue, Baltimore at 3205 Fait Avenue, and Aldine at 3310 East Baltimore Street. And not to be overlooked are the concrete backyards of Highlandtown, where friends, the imagination, and/or a simple toy or two were the components of play.

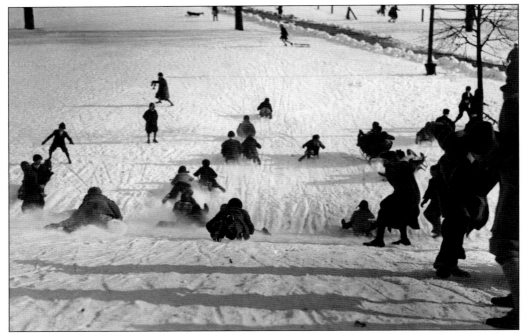

Snow, the hills of Patterson Park, and the limitless energy of the young and young at heart combine for an image only Bodine could capture, and he did in 1930. (Photograph by A. Aubrey Bodine, copyright Jennifer B. Bodine; courtesy of AAubreyBodine.com.)

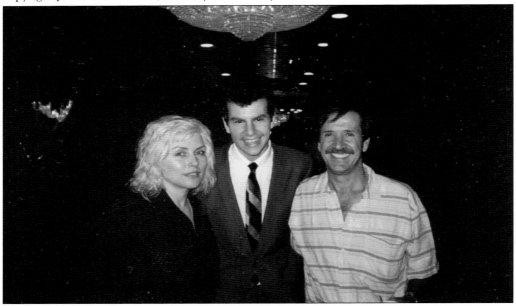

Hairspray was based on the life of legendary Baltimore radio and television host Buddy Deane. Portions of the original 1988 movie were filmed in Highlandtown. At a cast gathering, stars Deborah Harry (left) and Sonny Bono (right) pose with Vincent De Paul (Zannino), who, at the tender age of 15, appeared as the character Carlo, one of the *Corny Collins Show* dancers. (Courtesy of Felicia Zannino-Baker.)

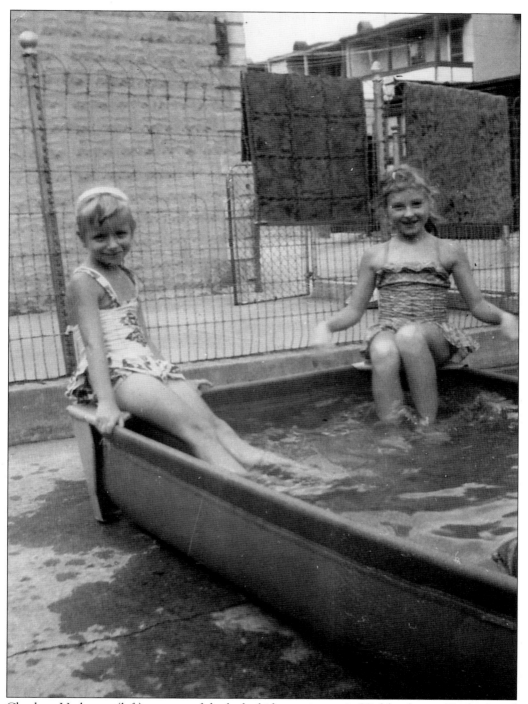

Charlene Umberger (left) was one of the lucky kids growing up in Highlandtown. Her backyard in the 700 block of South Conkling Street had a pool, albeit a modest one. In the summer of 1960, friend Mary Rice is catching some relief from the oppressive heat and humidity of Baltimore with Charlene. (Courtesy of Charlene Umberger.)

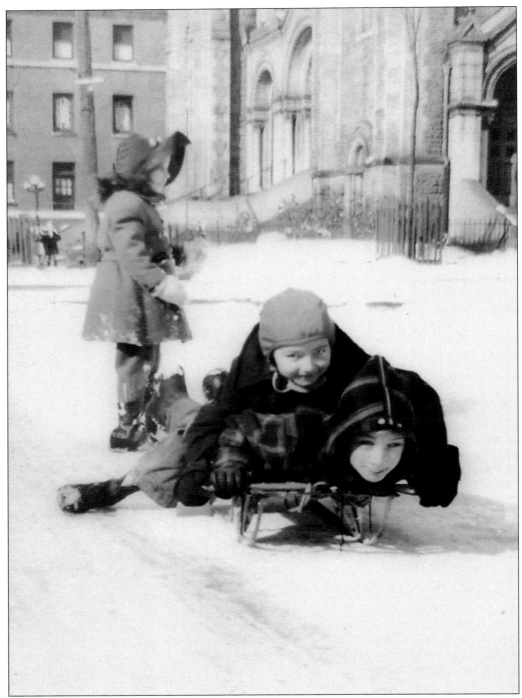

Heavy snowfalls in Baltimore are more the exception than the norm. But when they occur, the world can be one big playground, as seen in this photograph from the mid-1940s. Sledding past Sacred Heart of Jesus Church on Foster Avenue near Conkling Street, Don Ulsch is shown on the bottom, and Ron Ely is seen on top. The girl in the picture is unidentified. (Courtesy of Don Ulsch.)

In early 1957, Gary Helton, the author of this book, is seen as a young child on a swing at Patterson Park. The swings at the park were made of wood and painted black. Patterson Park bills itself as "Baltimore's Best Backyard!" today. (Author's.)

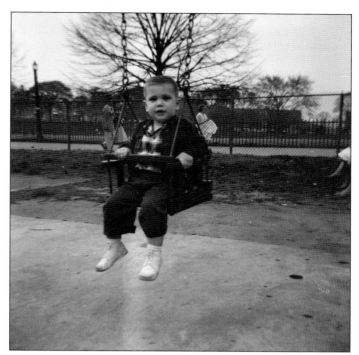

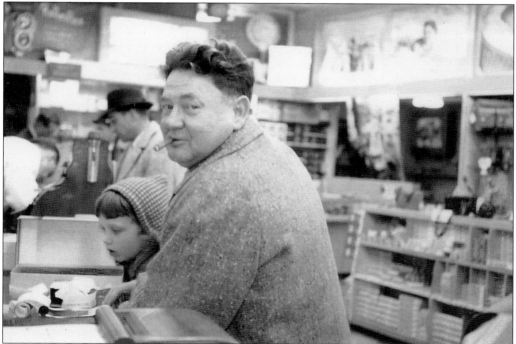

Playtime is not just for kids. It is for big people, too. Frank Hulseman was the author's favorite uncle. A carpenter by trade, he was, in reality, a big kid. His favorite pastime was photography, and he had all the latest gadgets. This shot from the mid-1960s was taken inside Binko's, a photography shop on the 300 block of South Highland Avenue and one of his favorite stores. (Author's.)

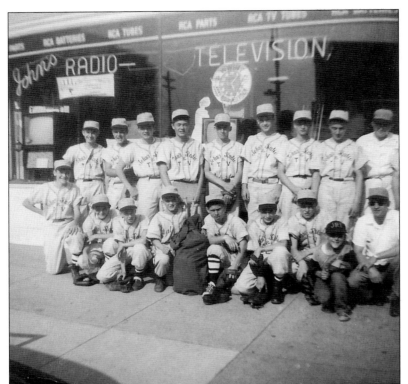

John's Radio & Television believed in giving back to the community. On this day, the baseball team it sponsored dropped by for a group photograph outside the shop on Highland Avenue. (Courtesy of Mary Moscato Chaikin.)

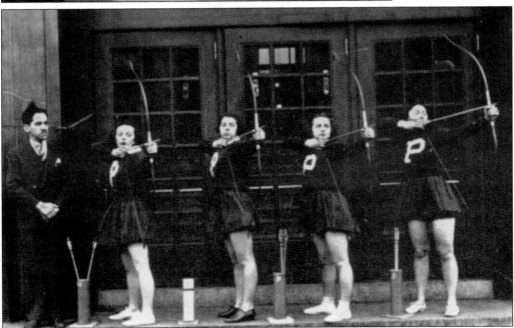

Many people would not dare make these ladies angry. The 1938–1939 Patterson Park High School women's archery team is shown taking aim from the steps of the "Big Red Schoolhouse." (Courtesy of Cecilia Trentowski.)

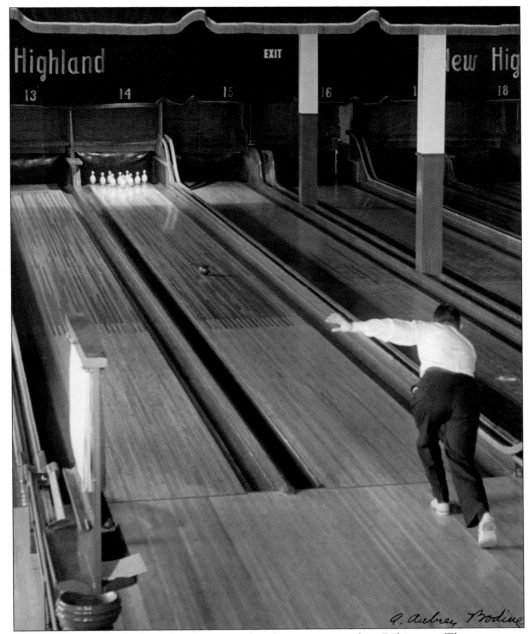

By most accounts, duckpin bowling is said to have originated in Baltimore. The sport was tremendously popular in the city for the first 75 years of the 20th century. Duckpin lanes seemed to be everywhere. Businessman Jimmie Marks opened the New Highland Bowling Center at 3801 Fleet Street in 1936 and operated the 30-lane duckpin house until his death in 1956. (Photograph by A. Aubrey Bodine, copyright Jennifer B. Bodine; courtesy of AAubreyBodine.com.)

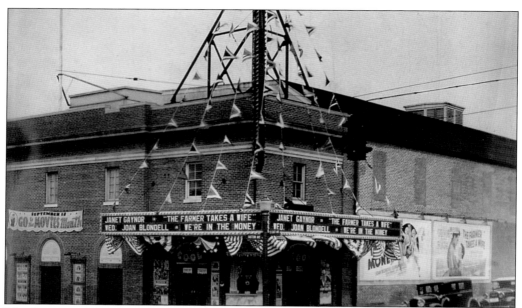

The Patterson Theater was a destination for Highlandtown movie fans until 1995. The original Patterson opened in 1910 as a movie theater, with a dance hall on the second floor. Razed in 1929, it was rebuilt and reopened the following year. When this photograph was taken in 1935, Henry Fonda's first film, *The Farmer Takes a Wife*, was showing. (Courtesy of the Creative Alliance at The Patterson.)

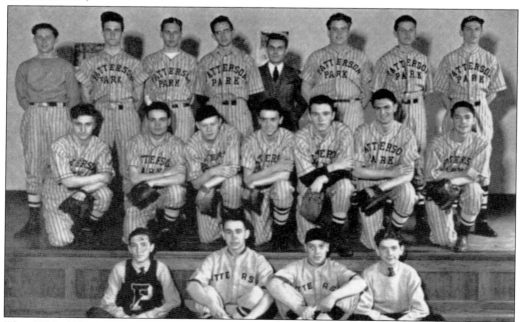

The 1938–1939 Patterson High School baseball team members got together for this group photograph. With the facilities of nearby Patterson Park, practice space was rarely an issue. The team has played its home games on Kane Street since the new Patterson High School opened in 1960. (Courtesy of Cecilia Trentowski.)

Like most youngsters of early Highlandtown, and every other part of urban America, the streets became these boys' playground. John (left) and Adolph Dollenger are the disheveled-looking pair in this photograph from around 1908. (Courtesy of John Meisenhalder.)

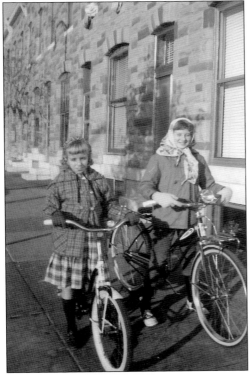

Friends Charlene Umberger (left) and Mary Rice are enjoying the outdoors again; this time, they are riding their bicycles. Bikes were prized possessions to the kids of Highlandtown, who had the 260-plus acres that encompass Patterson Park, along with neighborhood sidewalks and alleys, to explore and conquer. (Courtesy of Charlene Umberger.)

43

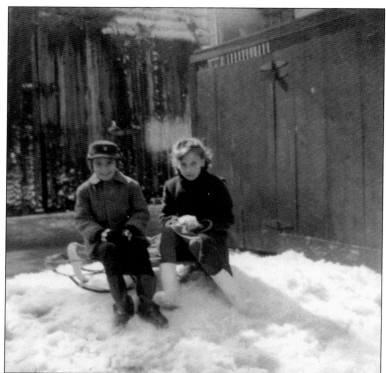

Few things generate a smile on a youngster's face faster than a good snowfall. Here, in the rear of 503 South Bouldin Street, are George Kispert and Nancy Olencz, pausing from their play just long enough to pose for this picture in January 1962. (Courtesy of Nancy Van Keuren.)

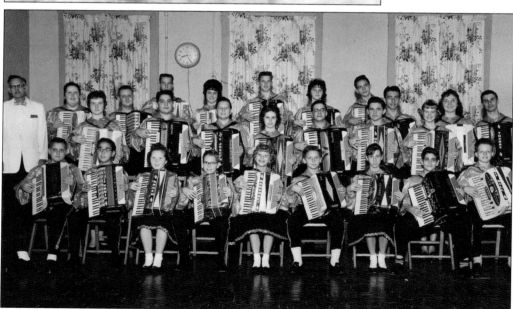

The Groll Variety and Accordion Band had 30 members aged 4 to 16 and performed for free at area hospitals, churches, and the like. The names of some of the youngsters can be seen on their accordions. LeRoy Groll, founder and leader of the group, is seen at the far left in the white jacket. Tom Trentowski, the contributor of this 1961 shot, is standing at the far right in the third row. He resides today in Bel Air, Maryland. (Courtesy of Tom Trentowski.)

44

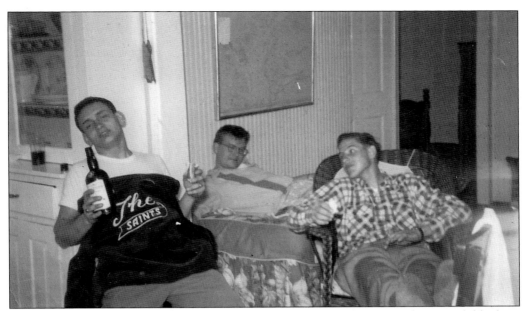

The Saints was an all-male club, which, if this 1950s photograph is any indication, did little or nothing. They did, however, have their group's name embroidered on jackets and enjoyed mugging for the camera. (Courtesy of Florence Sdanowich.)

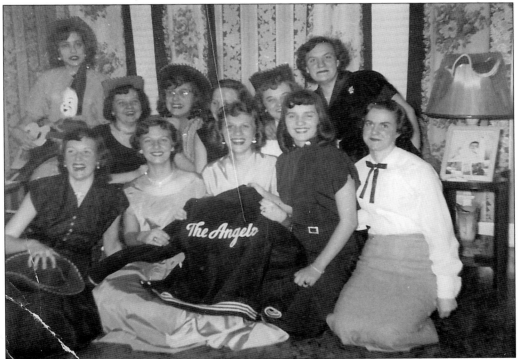

Not to be outdone by the Saints, the girls organized the Angels. They, too, had jackets with their club's name embroidered on the back and, like their male counterparts, did little more than hang out and goof off. (Courtesy of Florence Sdanowich.)

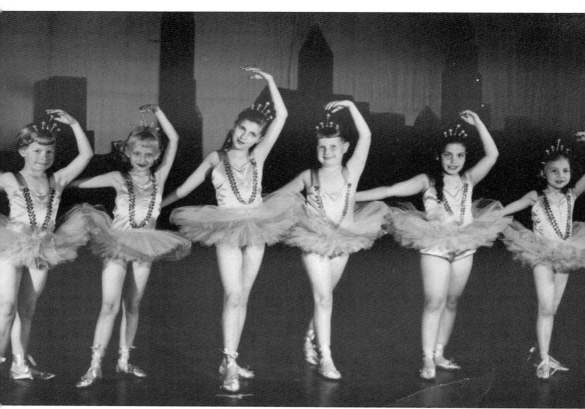

Students from Lola's School of Dance gave a recital each year, usually in the auditorium of Sacred Heart of Jesus School. The contributor of this 1959 photograph was then known as Margaret Olencz and is second from the left. The names of the others are unknown. (Courtesy of Margie Policastri.)

Johnny Long (left) excelled in many sports, including baseball and soccer. He practically lived in Patterson Park. Yet, his life came to a tragic end due to tuberculosis before his 18th birthday. This photograph, on a diamond in the park, was taken around 1930. (Courtesy of Nancy Van Keuren.)

In a party photograph from 1988, some dancers from the film *Hairspray* take time out for a little fun. Highlandtown native Vincent De Paul (Zannino), third from the right, was just 15 when he appeared in the film. He has since become a Hollywood actor, producer, and model. (Courtesy of Felicia Zannino-Baker.)

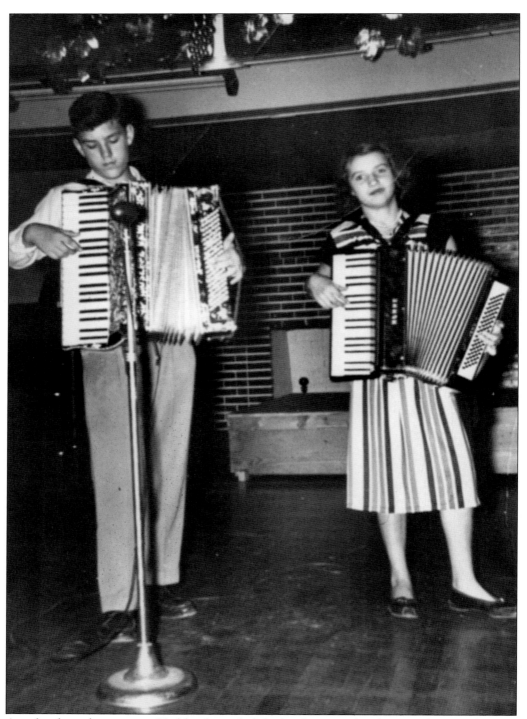

As a family tradition, many Highlandtown kids had to learn to play the accordion. In this shot from September 1949, Stanley Sdanowich and Florence Kielczewski performed for friends and neighbors. They would later become husband and wife. (Courtesy of Florence Sdanowich.)

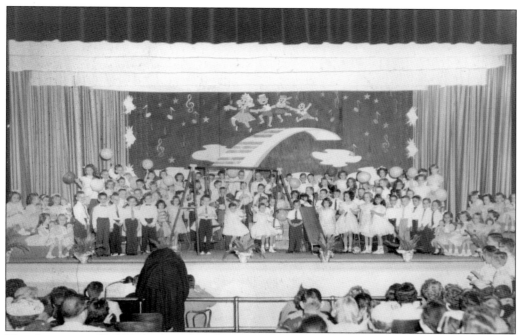

The show was called *Toyland*, and students presented it in May 1958 at Sacred Heart of Jesus School. Founded in 1873, Sacred Heart of Jesus remains one of Highlandtown's most active and influential churches. (Courtesy of Charlene Umberger.)

It is not extremely tall, just 60 feet in height, but the view from the top of the Patterson Park Pagoda can be awesome, especially when someone experiences it for the first time. Patterson Park Avenue is on the right in this 1965 image, and in the distance are Baltimore harbor and Fort McHenry. (Photograph by A. Aubrey Bodine, copyright Jennifer B. Bodine; courtesy of AAubreyBodine.com.)

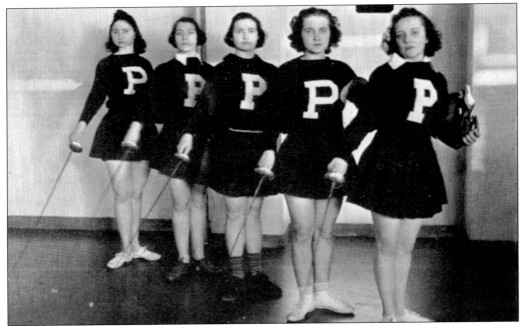

In the 1938–1939 school year, Patterson Park High School featured both boys' and girls' fencing teams. Eastern High was the only other city school that fielded a girls' team that season. Rosalie Eisman (center) placed second in that year's Maryland State Championship meet. (Courtesy of Cecilia Trentowski.)

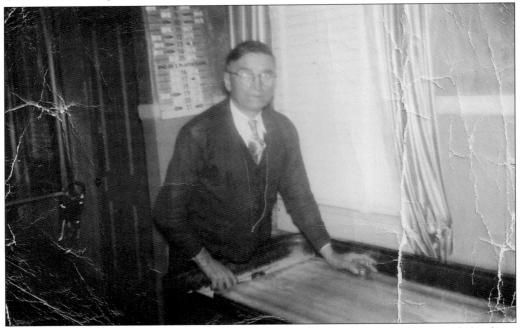

Social clubs, fraternities, and bars have always been great places to hang out with friends for cheap drinks, eats, and entertainment. In this undated picture, Joseph Olencz is at the shuffleboard table in Dempski's, located at Robinson and Dillon Streets. (Courtesy of Nancy Van Keuren.)

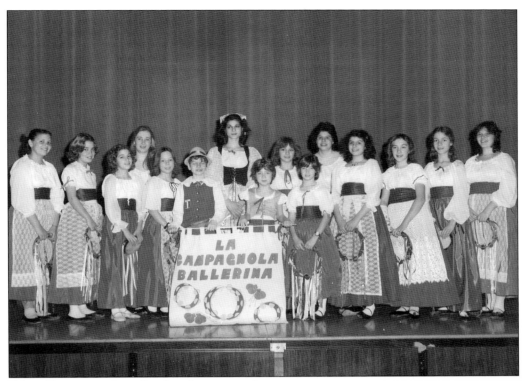

Felicia Zannino is the tall girl in the center of this 1970s group shot featuring the Mimi E. LaCampagnola Ballerinas, an Italian American musical troupe. "I was always the tallest girl," she reflects today. Felicia now owns and operates Magnolia Designs at 3211 Eastern Avenue, a residential and commercial interior design business that serves clients in Baltimore and Washington, DC. (Courtesy of Felicia Zannino-Baker.)

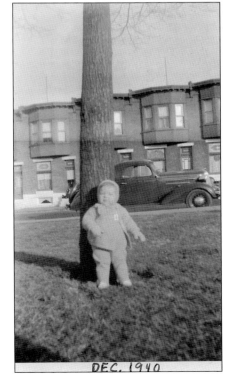

Patterson Park is a favorite play spot for the young and old alike. Propped up against a tree is one-year-old Elvera Dollenger in December 1940. (Courtesy of John Meisenhalder.)

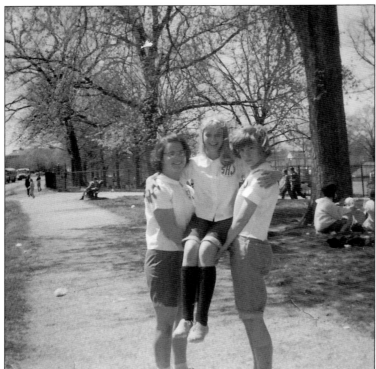

Gathered for the Catholic school inter-murals at Patterson Park are, from left to right, best friends Martha Tatchyn, Margie Olencz, and Sue Graver, all students at Sacred Heart of Jesus School. The photograph is from the late 1960s. (Courtesy of Margie Policastri.)

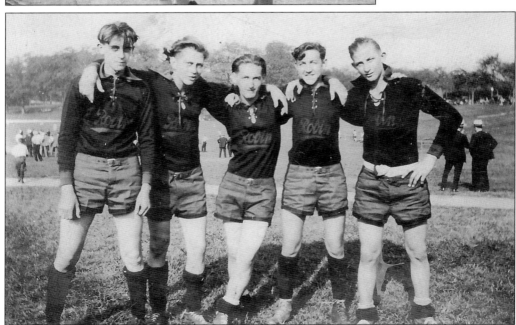

This 1930 photograph features players from the Robin Soccer Club of the Greater Baltimore Soccer League, which competed at Patterson Park. Pictured are, from left to right, Johnny Long, George Von Tram, Ben Tribull, John Foehrkolb, and Jimmy Benzing. They were all about 17 years old here. (Courtesy of Nancy Van Keuren.)

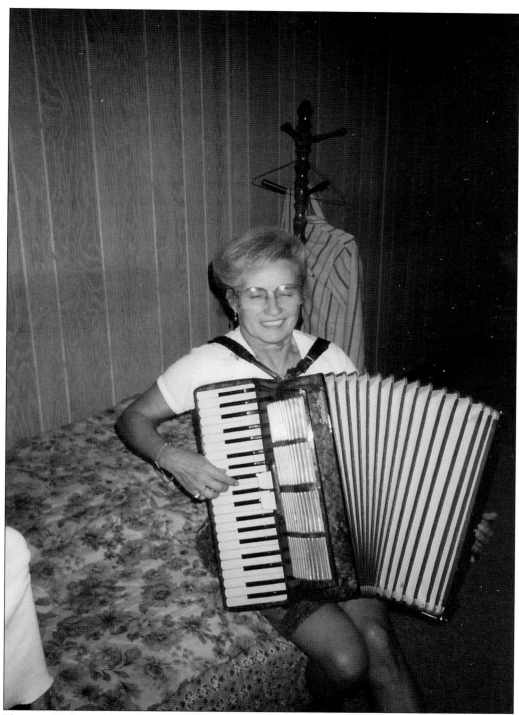

Florence Kielczewski met her future husband, Stanley Sdanowich, while taking accordion lessons as a youngster. She still breaks out the squeeze box on special occasions, as this 1994 photograph will attest. (Courtesy of Florence Sdanowich.)

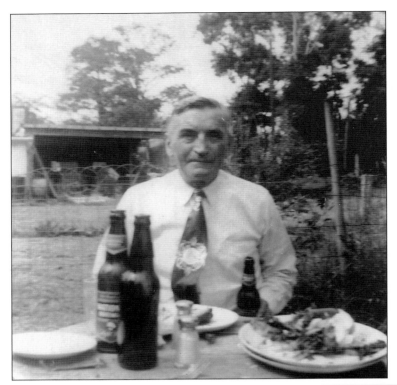

Joseph Olencz made his living in Bethlehem Steel's tin mill at Sparrows Point. But on this day, he was throwing back some suds, enjoying some National Boh, which was brewed just a few blocks from his Dillon Street home. (Courtesy of Nancy Van Keuren.)

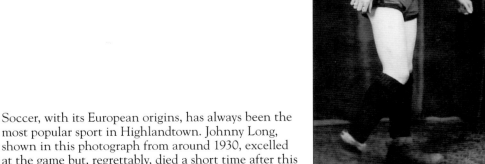

Soccer, with its European origins, has always been the most popular sport in Highlandtown. Johnny Long, shown in this photograph from around 1930, excelled at the game but, regrettably, died a short time after this picture was taken. (Courtesy of Nancy Van Keuren.)

Four

FASHIONABLE HIGHLANDTOWN

Historically, the words "fashion" and "Highlandtown" have not always belonged together. The community has, for the last several decades at least, been unwilling or unable to shed its image as fashionably challenged. The description is a generalization and, as such, is neither fair nor accurate. In fact, there was a time, not all that long ago, when such a criticism was totally unwarranted. Outside of work, generations of gentlemen dressed, well, like gentlemen: neatly coifed, wearing coats and ties, and topped with fashionable hats. And while a housedress and curlers may have been acceptable at home, ladies took great pains with their hair, makeup, and attire outside those confines. Frank Hulseman was a carpenter by trade. Yet, whenever he visited someone's home or dropped by Binko's for some photography supplies, he was always wearing a coat and tie. Andrew J. Ruppolt, the longtime manager of the Belnord and Grand Theaters, always came to work sporting a three-piece suit. And it was unheard of for someone to arrive for dinner at Haussner's without wearing the proper attire.

So, why does Highlandtown have a reputation for dressing "casually casual," and is this reputation truly deserved? Sociologists, economists, teachers, psychiatrists, psychologists, clergy, great universities, politicians, astrologers, tea-leaf readers, NPR, and Fox News can all get together to study and debate the topic, or readers can look at the photographs appearing in this chapter and decide for themselves.

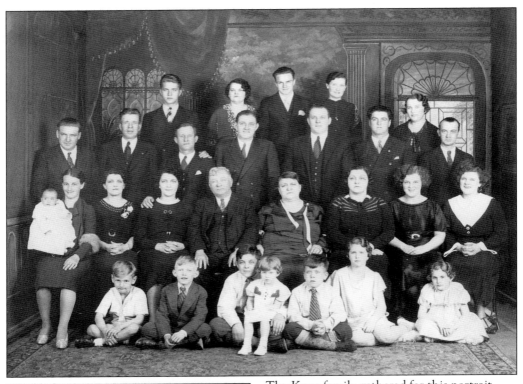

The Kress family gathered for this portrait in 1935. Patriarch John Kress and his wife, Margaret, are seated at the center. Kress was a locomotive engineer for the Pennsylvania Railroad for 51 years. (Courtesy of Debra Amend-Libercci.)

Mother Mueller's was situated on the northeast corner of Eastern and East Avenues and offered fountain service, sandwiches, and other tasty and tempting treats. Sisters Theresa and Florence Kielczewski posed for the camera there on this sunny day in the mid-1940s. Remembering the store's ice cream sundaes, Florence called them "awesome—I never tasted chocolate like that." (Courtesy of Florence Sdanowich.)

Pictured from left to right are Albert, Helen, and Al Rozanski in the 1940s. If Al looks like an old-time movie detective in his pinstripe suit, there is a good reason: he was one, working for the Baltimore City Police Department and, for a time, on a police boat in the harbor. (Courtesy of Florence Sdanowich.)

It is hard to say whether Popeye or Donald Duck caused a spike in the popularity of sailor suits in the 1930s; in any event, this photograph predates the cartoon characters by a decade. Eugene Ellison would eventually become a steelworker. But on this day, around 1920, the toddler was a sailor. (Courtesy of Debra Amend-Libercci.)

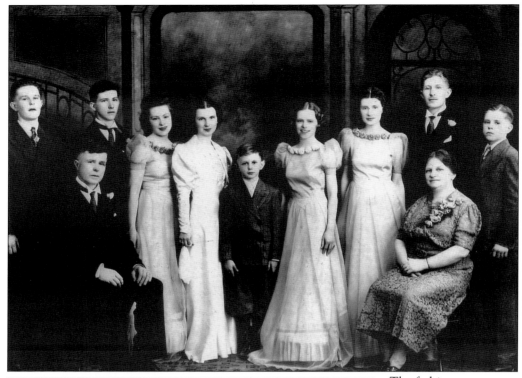

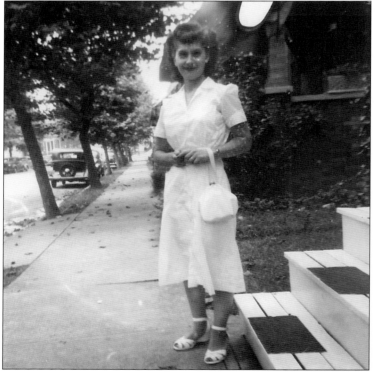

The fashions suggest the 1920s in this formal portrait of the von Paris family. Bonaventure von Paris Sr., under whose leadership the von Paris moving and storage business flourished, is seated on the left. (Courtesy of John von Paris.)

Elizabeth Helton (1930–1999) is dressed in white for the summer heat and humidity of Baltimore in this shot from around 1950 on the 700 block of South Grundy Street. It could be that she was headed for her job at the Mikulski Brothers Bakery on Eastern Avenue. (Author's.)

The car is a Buick LeSabre, probably from 1964, and the little girl with the Princess Leia hairstyle is Helen Krupa. Her white gloves and shoes suggest that she may have been on her way to church or Sunday school this day. (Courtesy of Tiffany Bock.)

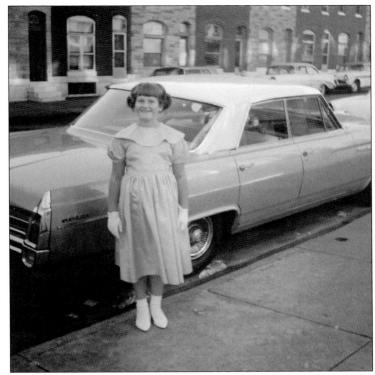

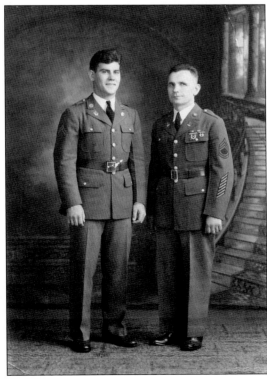

During the World War II years, formal portraits of servicemen in uniform were common and popular. This 1940s photograph features Army corporal Joseph Rozanski (left) and Sgt. John Sdanowich, his uncle. (Courtesy of Florence Sdanowich.)

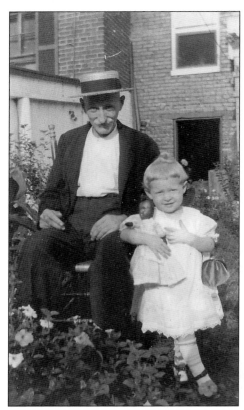

Clutching a purse and her favorite doll, Elfreda Dollenger poses with her grandfather William Cappeller in the yard of the family home at 202 South Clinton Street. Cappeller has his straw hat on to protect himself from the August heat in this 1920 photograph. (Courtesy of John Meisenhalder.)

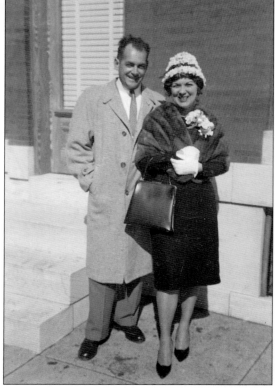

The fashions are clearly 1960s, and the date confirms it. It is 1961, probably Easter. JFK is in the White House, gasoline averages 31¢ a gallon, and Chester and Anne Amend Peters pose for the camera on Potomac Street. (Courtesy of Debra Amend-Libercci.)

Orville Helton is handsome and stylish in his tan, double-breasted overcoat, which he wore to keep out the chill of winter. This image, taken in Patterson Park around 1950, is rare in that he seldom wore a tie—a tradition his son, the author of this book, is pleased to continue. (Author's.)

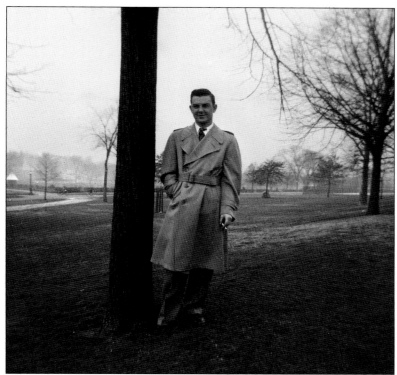

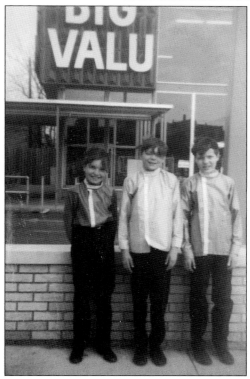

John, David, and Louis Hall grew up at 502 South Eaton Street, right off the avenue. For many families, including the Halls, money could be scarce at times, and fashionable clothing had to take a backseat. In this 1969 photograph, the boys are attired in hand-me-down Nehru shirts in front of the old Big Valu, now The Markets at Highlandtown. (Courtesy of Barbara Cosner Hall.)

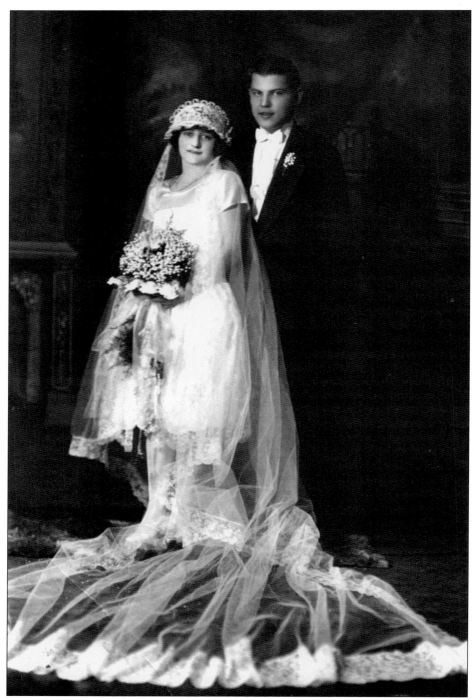

Mamie and James Rozanski posed for this formal wedding portrait around 1930. Jim was one of Highlandtown's many barbers. His shop was located on Fleet Street. Barbershops were found along Fait Avenue, Bouldin Street, Ellwood Avenue, and elsewhere. If one was busy, it was common for a customer to simply walk to the next shop. (Courtesy of Florence Sdanowich.)

Walter Olencz (1924–1982) looks every inch a man of 1950s America in this photograph taken in Patterson Park. Sporting a hairstyle like Elvis and white shoes like Pat Boone, it is no wonder he once worked at WEBB radio. Then, as now, fashion trends were often driven by the celebrities of the day. Ellwood Avenue is in the background of this 1957 image. (Courtesy of Nancy Van Keuren.)

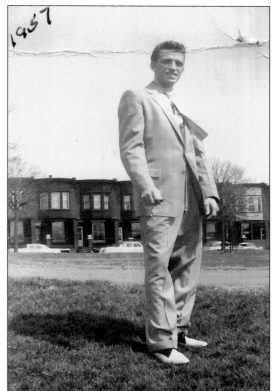

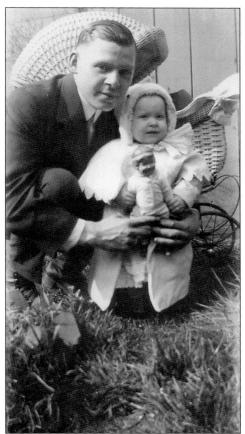

It is hard to believe that the grubby little boy on page 43 would turn out so well, but he did. Proud father Adolph Dollenger is shown in this 1918 photograph with his one-year-old daughter Elfreda, who would live to see the dawn of the 21st century. (Courtesy of John Meisenhalder.)

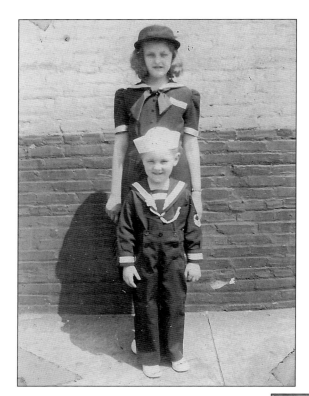

Here are more sailor suits. Modeling on Foster Avenue in the mid- to late 1940s are John "Jacky" Long and his sister Margaret. Patriotism in Highlandtown has never been in short supply. That was particularly evident during World War II. (Courtesy of Nancy Van Keuren.)

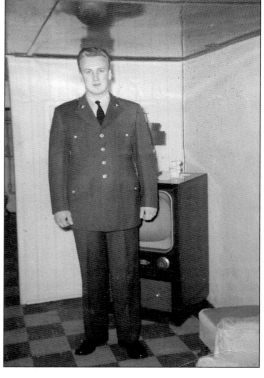

Pictured around 1960 is another Highlandtown young man in uniform. Don Amend worked at Bethlehem Steel at Sparrows Point after his Army discharge, retiring in the 1990s. This photograph was taken in the basement (note the low ceiling) of the family's Potomac Street home. (Courtesy of Debra Amend-Libercci.)

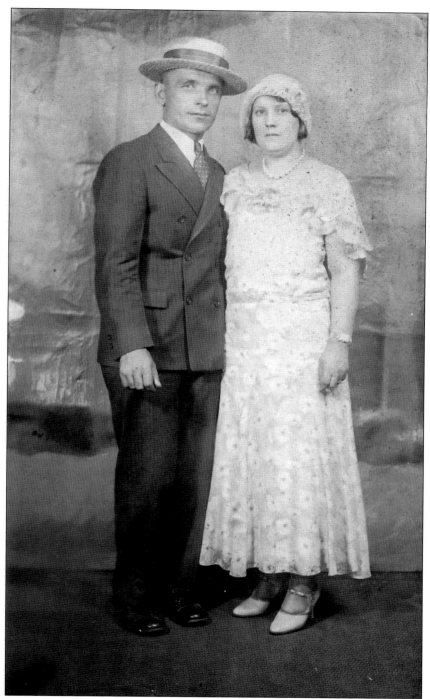

The fashions of 1932 are modeled in this photograph of John and Anna Sdanowich. A straw topper for men was normally worn during the warm months—it was white to repel the sun's rays, lightweight, and allowed air to flow in and out. Anna's light-colored dress and hat suggest the photograph was taken before Labor Day. (Courtesy of Florence Sdanowich.)

The white marble steps and facade are gleaming, and Adolph Dollenger (1896–1962) is all spit and polish on South Clinton Street in 1912. His ensemble included a stiff white (and likely uncomfortable) collar. (Courtesy of John Meisenhalder.)

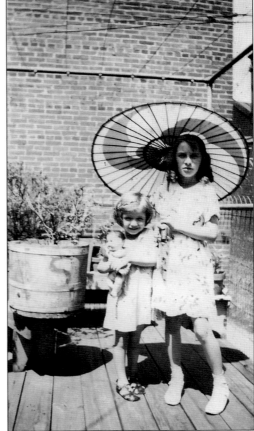

It is 1940, and the Kielczewski sisters strike a pose in their Highlandtown backyard. Theresa is on the left, and Florence holds a fashionable parasol that came from the New York World's Fair of 1939. (Courtesy of Florence Sdanowich.)

Formally attired in white tie and tails is Walter Olencz, posing with his sister Helen Oleniacz, whose beautiful gown is covered in ruffles and lace. The two were members of a wedding party in 1940. Helen retained the Polish spelling of her last name, while Walter opted for an Americanized version. (Courtesy of Margie Policastri.)

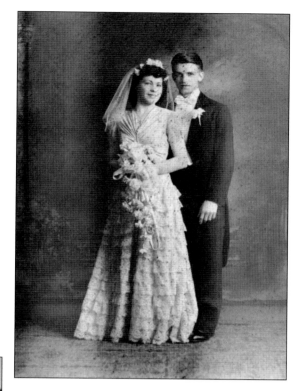

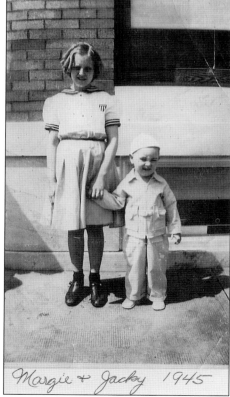

Margie + Jacky 1945

Margie and Jacky Long pose outside their Foster Avenue home in this 1945 photograph. The war was coming to an end, and the world was about to be come a much happier place again. (Courtesy of Nancy Van Keuren.)

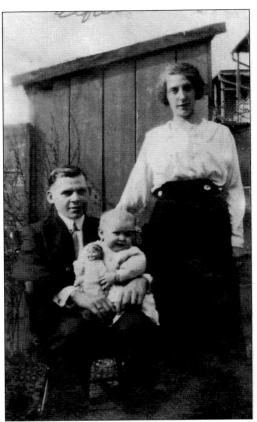

Indoor toilets were not a luxury in the homes of early Highlandtown. Backyards featured "earth houses," the urban equivalent of the country outhouse. With their earth house in the background, Adolph and Elsie Dollenger pose with their daughter Elfreda in 1918 in the yard of 202 South Clinton Street. (Courtesy of John Meisenhalder.)

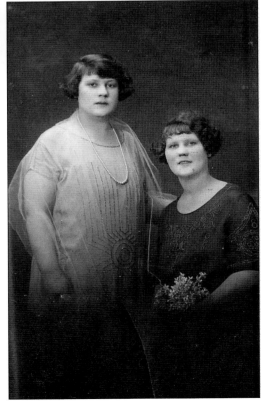

Rozanski sisters Anna (left) and Laura (also known as "Lottie") made their home at 823 South Decker Avenue. This undated portrait is believed to have been taken in the 1920s. (Courtesy of Florence Sdanowich.)

Despite his youth and athleticism, Johnny Long had just over a year to live when this photograph was taken in Patterson Park on a snowy day in January 1930. His death at age 17 in February 1931 was attributed to tuberculosis. This disease took 78,890 American lives in 1932, compared to just 544 in 2007. (Courtesy of Nancy Van Keuren.)

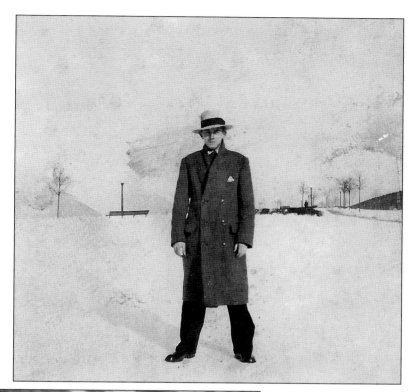

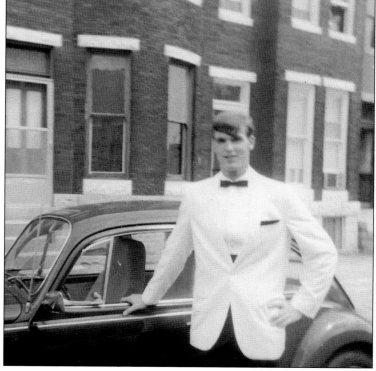

Jim Charvat recalls that he was en route to a wedding when this shot was taken in the 200 block of North Luzerne Avenue in 1968. A biking enthusiast today, he is seen here with his new green 1968 Volkswagen Beetle that cost $1,900 "on the street," or $51 a month. (Courtesy of Jim Charvat Jr.)

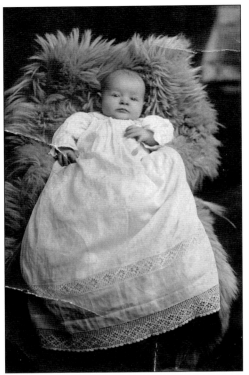

Christening robes or dresses, like the one worn by Elfreda Dollenger in this photograph, were common on children of both sexes. The tradition continues today in some families and faiths. The ceremony for Elfreda on this day in December 1917 was at St. Paul Lutheran Church located at 3131 East Baltimore Street. (Courtesy of John Meisenhalder.)

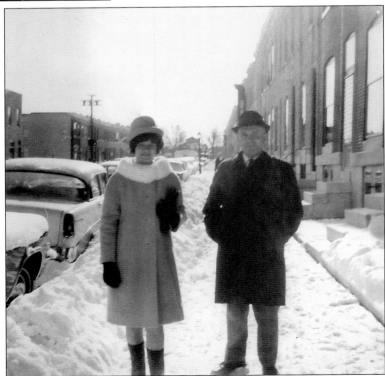

Here is another snowy day in the early 1960s, and Barbara Odalk and Frank Krupa are shown dressed for the winter weather on Luzerne Avenue. (Courtesy of Tiffany Bock.)

Second-grader Margie Olencz smiles for the photographer on the occasion of her First Holy Communion in May 1959. The ceremony took place at Highlandtown's Sacred Heart of Jesus Church. (Courtesy of Margie Policastri.)

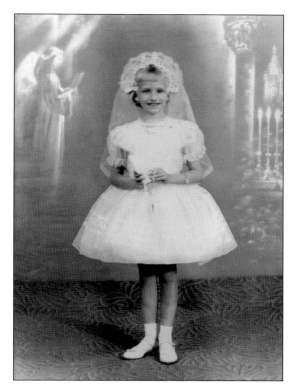

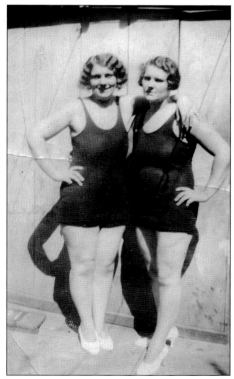

The Rozanski sisters, Anna (left) and Lottie, model the latest in 1920s swimwear—probably considered daring for the day—in the yard of their Highlandtown home at 823 South Decker Avenue. (Courtesy of Florence Sdanowich.)

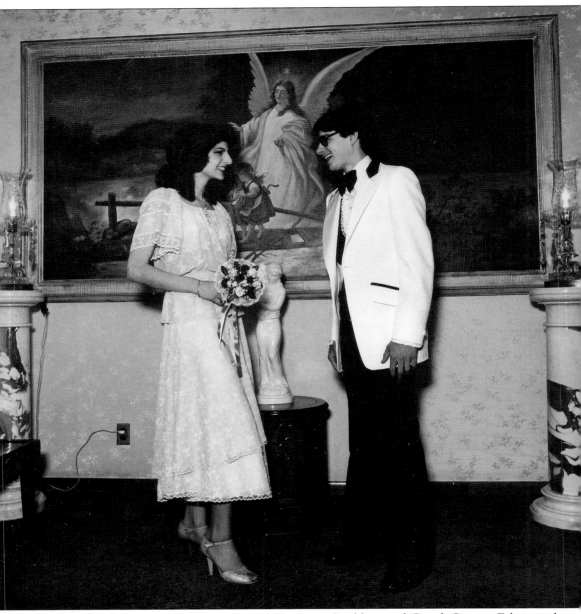

At the family business, Zannino Funeral Home, at Conkling and Gough Streets, Felicia and Charles Zannino are all dressed and seem to be ready for a dance or prom. There is no doubt that a proud papa or mama took this photograph in 1979. (Courtesy of Felicia Zannino-Baker.)

Five

REMEMBRANCES, RELICS, AND RENEWALS

It has been said that people are "the sum total of [their] life experiences." Simplified, it means who a person is today has been influenced by the people and events of his or her past. At birth, everyone is a blank canvas, unmolded clay, sheet music without notes, and so on. Some of the people and events that influence human beings are common, regardless of one's heredity and environment, however, parents, siblings, births, deaths, teachers, clergy, peers, accidents, illnesses, lean times, bountiful times, and so on vary greatly from one person to the next. There are also the limited occurrences that impact smaller groups or individuals. Some events are exclusive to Highlandtown's heritage, culture, families, neighborhood, faith, and the like.

Highlandtown remains one of Baltimore's most interesting and unique communities. Someone who was raised on a farm or aboard a houseboat would not be able to relate to the experiences of a person who grew up in Highlandtown, and vice versa. The objective for this chapter was to find images that captured influential moments in time—episodes that, while long ago, have stayed as fresh in the minds of those who experienced them as if they occurred yesterday. Perhaps the significance of these events was not understood at the time they occurred, however, their lasting impacts are known. Some were major events or celebrations. Others occurred in the blink of an eye. Many were happy. A few were tragic. They are the places many have been to, the good and bad times experienced by all, and the people encountered along the way. They are journeys, and they uniquely belong to Highlandtown. But as people pass and places and events fade from memory, relics remain, and renewal springs up amongst them.

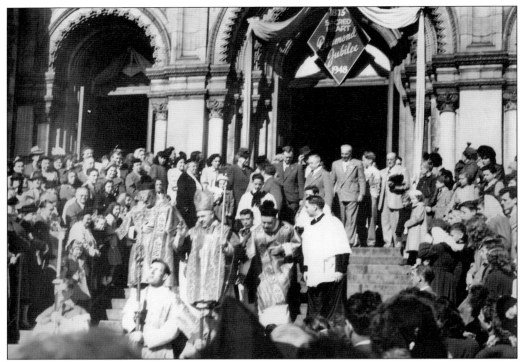

It seems as though all of Highlandtown, parishioners or otherwise, turned out for the public ceremonies marking the Diamond Jubilee, or 75th anniversary celebration, of Sacred Heart of Jesus Church in 1948. (Courtesy of Don Ulsch.)

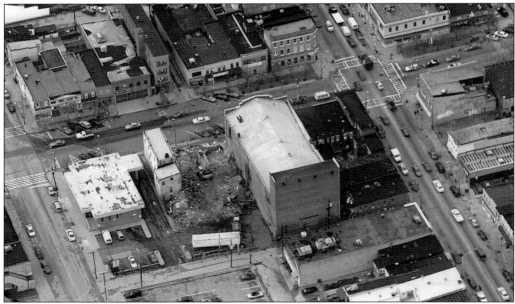

Few issues have been as divisive in recent years as the 2004 demolition of the iconic Grand Theater. This aerial shot shows that the old Highlandtown Café and Little Tavern have already fallen to the wrecking ball. (Courtesy of Ed Dobbins.)

Here is a dizzying view rarely seen by most. In 1965, photographer A. Aubrey Bodine captured this image of the spiral stairway inside the Patterson Park Pagoda. What Ansel Adams was to western American photography, Bodine was to Chesapeake Bay country. (Photograph by A. Aubrey Bodine, copyright Jennifer B. Bodine; courtesy of AAubreyBodine.com.)

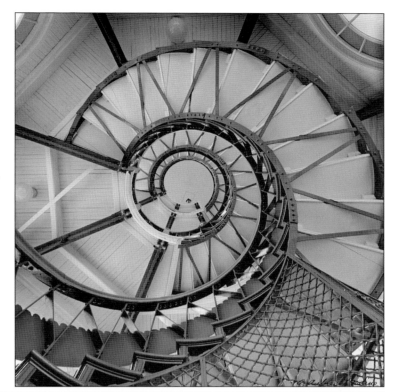

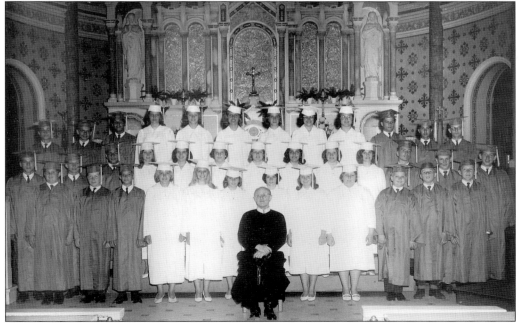

Sacred Heart of Jesus School eighth graders, section 8-C, are gathered for this formal photograph taken inside the parish in 1965. Margie Policastri is the second girl from the left in the first row. (Courtesy of Margie Policastri.)

When young Frank Rozanski died in 1938, his viewing and funeral were held at the family home, 823 South Decker Avenue. Having a funeral at home, complete with pictures of the deceased, was a respectful Highlandtown tradition that has long since lapsed. (Courtesy of Florence and Stanley Sdanowich.)

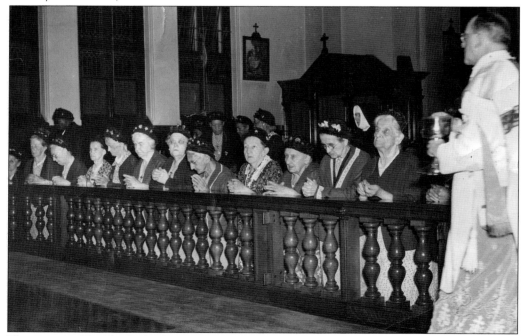

The women of St. Elizabeth of Hungary Church are gathered in prayer at the East Baltimore Street parish. They are about to receive Holy Communion in a special 1945 service held in response to the end of World War II. (Courtesy of Don Ulsch.)

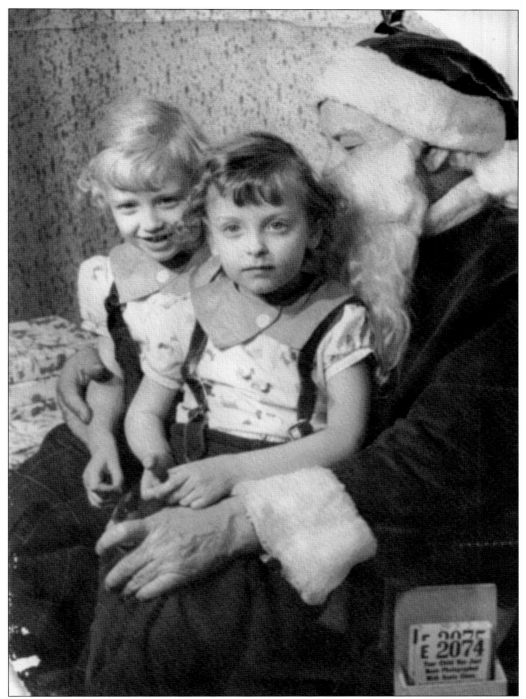

When looking back at vintage photographs of children with Santa, the adjective "precious" often comes to mind. It can certainly be said of this 1957 image of the Olencz sisters, Margie (left) and Nancy, with jolly Saint Nicholas at the old Epstein's Department Store, a familiar stop for generations of Highlandtown shoppers. (Courtesy of Nancy Van Keuren.)

Before it became a church, S. Hiken Formal Wear occupied this building located at 417 Eaton Street. Still earlier, it was one of Highlandtown's many bowling establishments. Today, souls are saved where duckpins once flew. (Author's.)

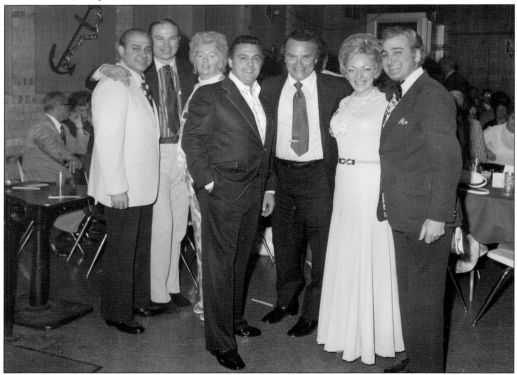

Bud's was one of Highlandtown's most popular eateries and watering holes. On this night in the 1970s, former National Basketball Association coach and referee Charlie Eckman dropped by. A popular sportscaster on WFBR radio at the time, "Coach," as he was known, is seen here (third from right) with an unidentified group. Behind them are, from left to right, Bud Paolino, Bob "Rabbit" Pomerlane, and Bud's wife, Annabelle. (Courtesy of Jim Baker.)

Baltimore's blizzard of 1966 left snowdrifts as tall as the tops of cars, as Pearl Adams demonstrates in this photograph. Travel everywhere around the city was slow at best and mostly by foot, which was the case here in the 800 block of South Curley Street. (Courtesy of Don Ulsch.)

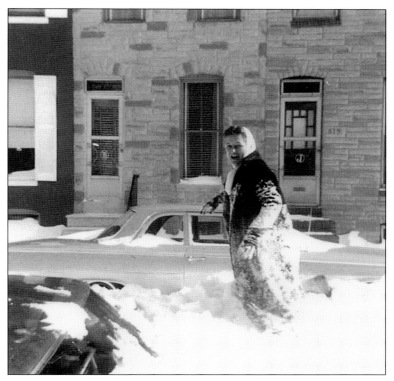

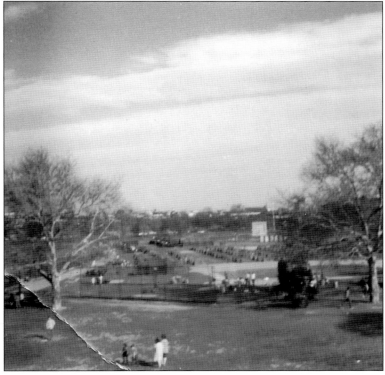

It was a sad and uncertain time when Maryland National Guardsmen camped in Patterson Park in April 1968—the first such military presence in the park since the civil war. The Reverend Dr. Martin Luther King had just been assassinated, and racial unrest followed in many American cities, including Baltimore. (Courtesy of Tiffany Bock.)

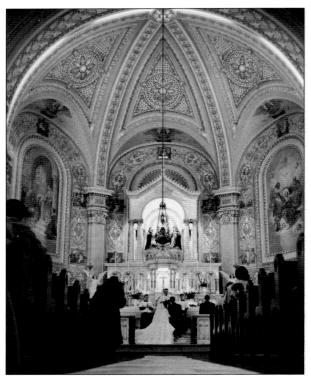

The beautiful interior of Sacred Heart of Jesus Church is evident in this undated photograph. (A rare image from 1908 and the church's cornerstone ceremony can be found on page 20 of Images of America: *Highlandtown*.) (Courtesy of Florence Sdanowich.)

Over 80 years of exposure to the elements has left it pitted and oxidized, but the bronze plaque commemorating construction of the Eastern Avenue underpass remains in its usual spot at Eastern Avenue and Haven Street. (Author's.)

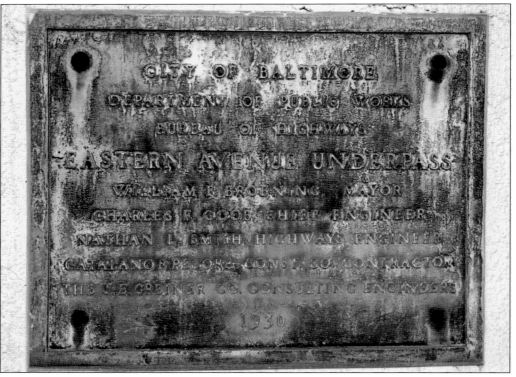

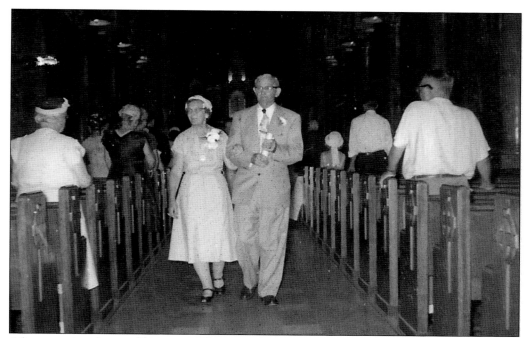

After renewing their wedding vows, Theresa and John Long are photographed walking arm in arm down the aisle of Sacred Heart of Jesus Church en route to a celebration of their 50th wedding anniversary with family and friends. (Courtesy of Florence Sdanowich.)

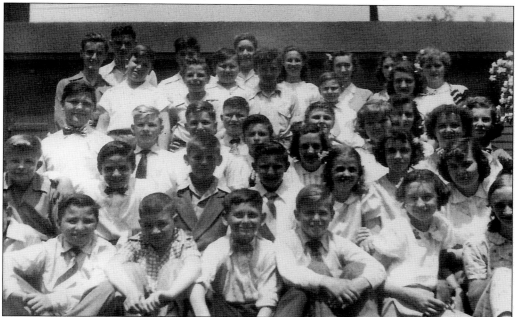

Well dressed and all smiles, Sacred Heart School's section 8-A poses for this group shot in the school's courtyard. When this photograph was taken in 1951, gasoline was 20¢ a gallon, a six-pack of Coca-Cola would set a thirsty family back 37¢, and the total cost for a new Ford car was as little as $1,425. (Courtesy of Don Ulsch.)

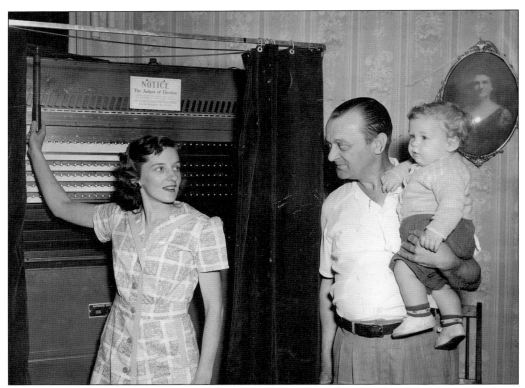

Some longtime Highlandtown residents may remember when going to the polls sometimes meant going to a neighbor's house. Fred Amend (right) is preparing to cast his vote at the home of a Mrs. Hrska in the 1940s. (Courtesy of Debra Amend-Libercci.)

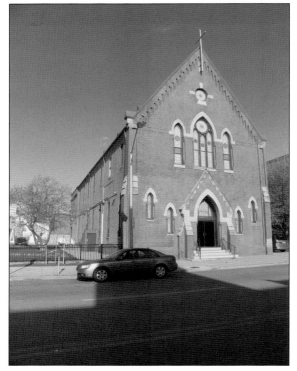

Founded by Welsh immigrants in the 1880s, Abbott Memorial Presbyterian Church at 3426 Bank Street takes pride in its community service and includes, as part of its mission, the desire to help build a great city for all. (Author's.)

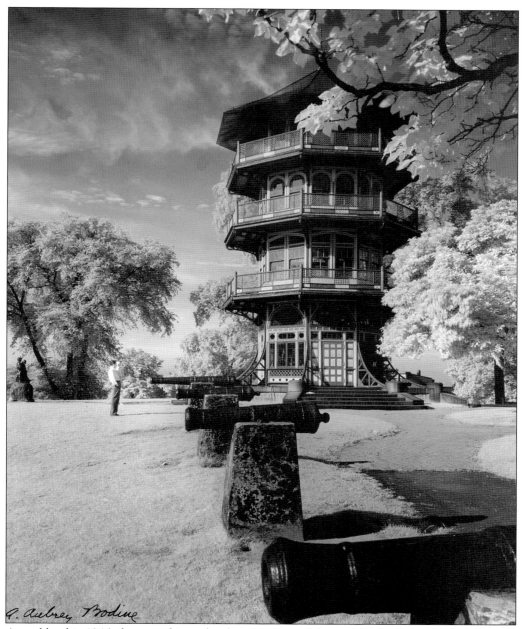

Arguably, this 1946 photograph may be the most beautiful image of the Patterson Park Pagoda that has ever been made. The cannons serve as a reminder to current and future generations of the efforts in 1814 to defend Baltimore from invading British troops at the site once known as Hampstead Hill. (Photograph by A. Aubrey Bodine, copyright Jennifer B. Bodine; courtesy of AAubreyBodine.com.)

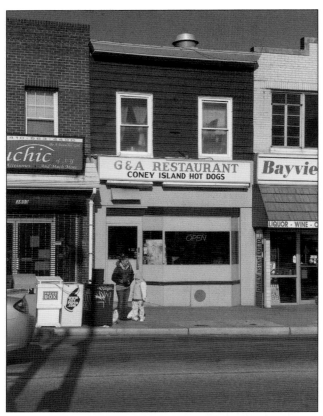

G&A Restaurant at 3802 Eastern Avenue is a living relic. A "One Up" is the restaurant's famous Coney Island hotdog with chili, mustard, and raw onions, which must be enjoyed with a side order of gravy fries for the full G&A experience. Family owned and operated since 1927, the restaurant was featured recently on the Food Network television program *Diners, Drive-ins, and Dives.* (Author's.)

Perhaps the most unique group of high school students one will ever see, this is the Patterson Park High School taxidermy club. Members gathered for this group picture on a winter day just after lunch during the 1938–1939 school year. Several students were feeling a bit "stuffed." (Courtesy of Cecilia Trentowski.)

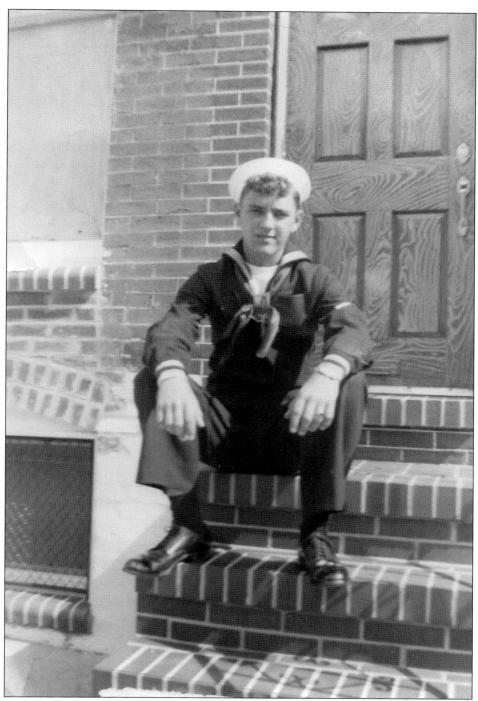

Except for his time in the Navy, Stanley Sdanowich has lived in Highlandtown his entire life. On this day in the 1950s, he was enjoying some much-deserved downtime on the steps of 831 South Decker Avenue. Stanley, or "Stash" to friends and family, now lives on South Streeper Street. (Courtesy of Florence Sdanowich.)

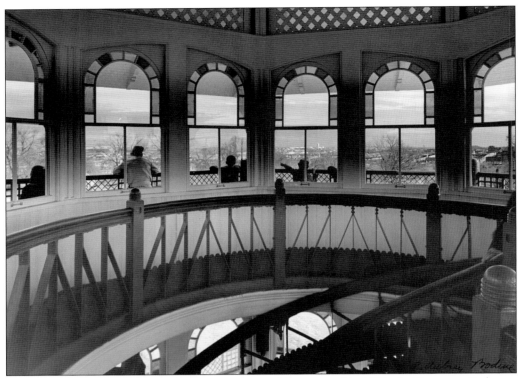

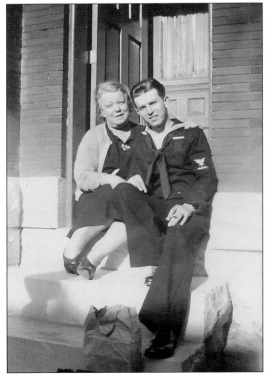

Constructed in 1891, the Patterson Park Pagoda was, for a time, neglected and a target of vandals—so much so that demolition was considered in the 1990s. Restored to its original beauty, the pagoda, in concert with the elevation of Hampstead Hill, offers visitors thrilling views of the surrounding neighborhoods. (Photograph by A. Aubrey Bodine, copyright Jennifer B. Bodine; courtesy of AAubreyBodine.com.)

Home on leave from the Navy, George Smith and his mom had this moment together on the white marble steps of their Luzerne Avenue home. Like all members of the military, George was the source of both motherly pride and concern during his time in the service. After his discharge, George worked for Smith's Grocery Store at Jefferson and Streeper Streets. (Courtesy of Jim Charvat Jr.)

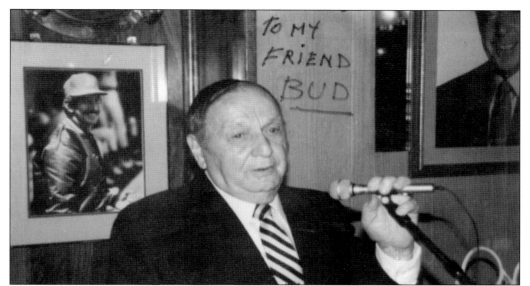

Dominic "Mimi" DiPietro (1905–1994) was a colorful longtime Baltimore city councilman and the unofficial mayor of Highlandtown who, at the 1993 papal visit in Baltimore, addressed Pope John Paul II as "Mister Pope." In the background of this 1980s photograph, taken at Bud's, are images of baseball's Billy Martin and Joe DiMaggio, who were also frequent visitors to the Highlandtown restaurant. (Courtesy of Jim Baker.)

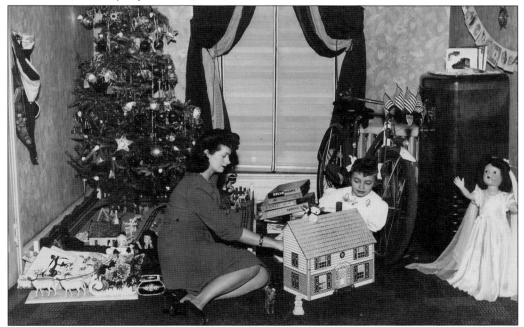

For Christmas in 1946, lucky eight-year-old Carol-Anne Sealover got a brand-new bike from her grandfather. She is pictured here with her mom, Regina Sealover, in their Highlandtown home located at 818 South Conkling Street. The bride doll in the picture is wearing a dress made by Regina from the slip of her wedding dress, and the veil was from Carol-Anne's First Holy Communion. (Courtesy of Shelley Sealover.)

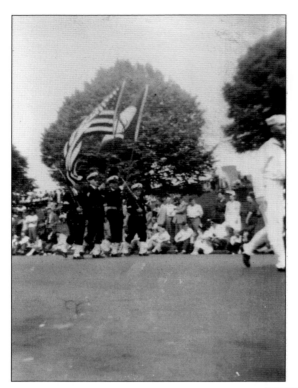

Highlandtown's I Am an American Day Parade was an annual highlight on Labor Day weekend. Most spectators honored the time-old tradition of standing when the nation's colors passed, as evidenced in this early 1950s photograph of the parade route on Linwood Avenue. (Courtesy of Don Ulsch.)

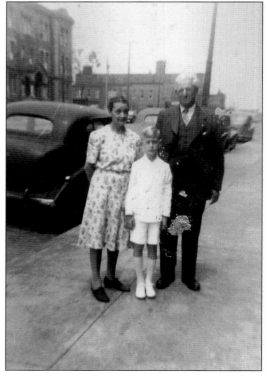

Tall even as a youngster, Donald Ulsch poses with his grandparents Mary and Joseph Ulsch in the 600 block of South Conkling Street on the occasion of his First Holy Communion in the 1940s. Ulsch, now retired, stands well over six feet today. (Courtesy of Don Ulsch.)

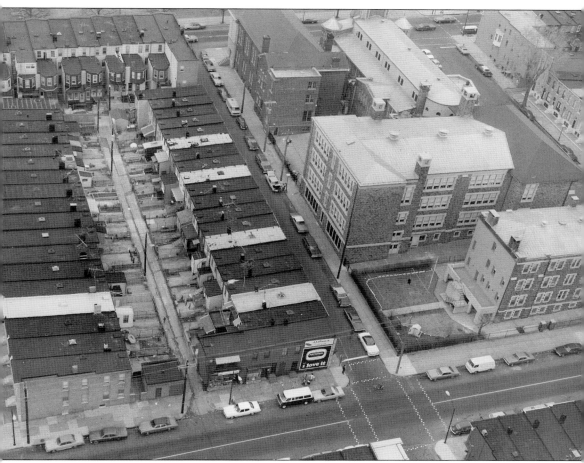

Here is a 1970s aerial view showing the intersection of Kenwood and Fairmount Avenues near the bottom. Joe the Shoemaker's shop is on the corner with the National beer advertisement. (Courtesy of Joe LaPaglia.)

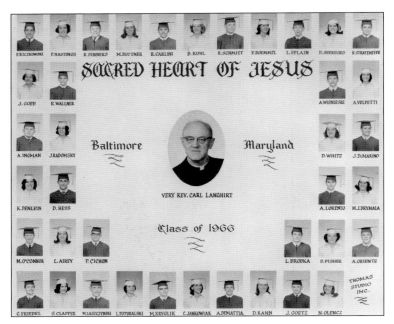

Sacred Heart's eighth grade class of 1966 is shown in this image. The last names of the students serve as a testament to the ethnic diversity of Highlandtown, with an abundance of German, Polish, and Italian families represented. (Courtesy of Nancy Van Keuren.)

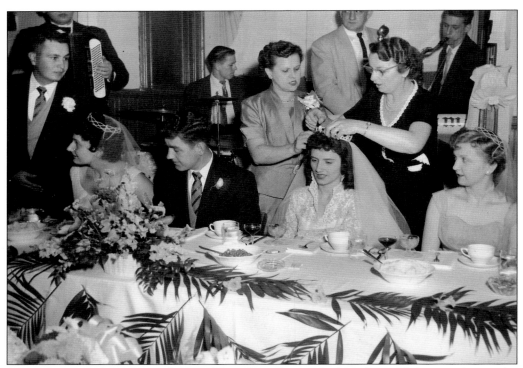

Emma Summers (standing at left) and Josephine Ostrowski (standing right) are replacing the bride's veil with a Polish cap at the wedding of Florence Kielczewski and Stanley Sdanowich. Seated at the far left is Mitzi Malenski, and at the far right is Thresa Kosinski. Needless to say, the band played more than a few polkas on this day. (Courtesy of Florence Sdanowich.)

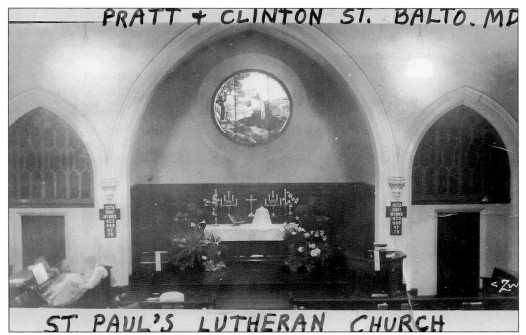

This undated image of the interior of St. Paul Lutheran Church appears to be from the 1930s. In 2010, a new parish, Breath of Life Lutheran, was established to share the 80-year-old building at Pratt and Clinton Streets. Both are under the caring and energetic leadership of Pastor Mark Parker. (Courtesy of John Meisenhalder.)

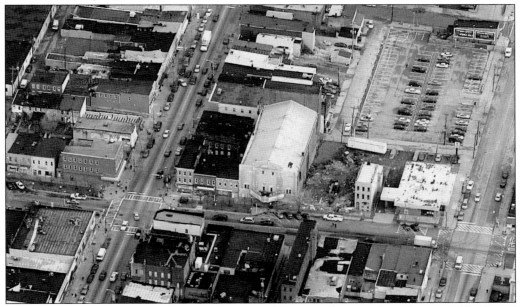

From the air, the large building at the center of this 2004 photograph is the venerable Grand Theater—its marquee is still visible above the sidewalk at 511 South Conkling Street. Just days away from demolition, the site would soon after become the Southeast Anchor branch of the Enoch Pratt Free Library of Baltimore. (Courtesy of Ed Dobbins.)

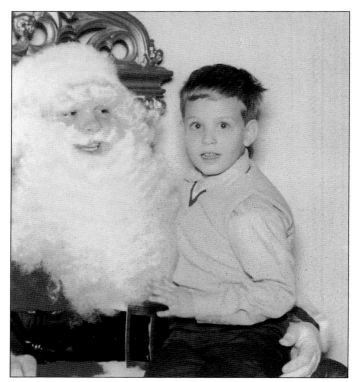

It is Christmas at Epstein's Department Store once again, and Joseph Olencz takes his turn sitting on Santa's lap. A closer examination of this 1964 photograph reveals that beneath the hair and whiskers, Mr. Claus appears much too young to be a "jolly old elf." (Courtesy of Nancy Van Keuren.)

Sacred Heart of Jesus Church at 600 South Clinton Street appears to be filled to capacity for services and ceremonies associated with its 75th anniversary in 1948. (Courtesy of Don Ulsch.)

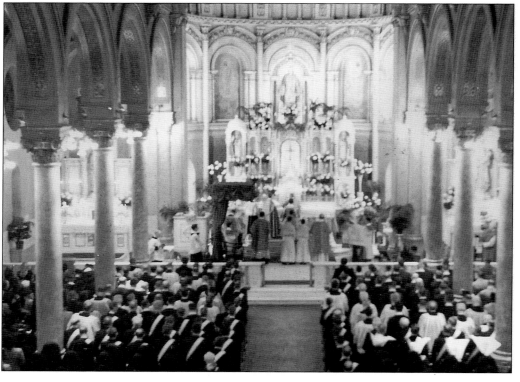

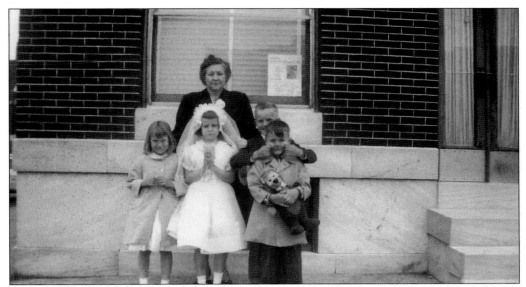

It is first Holy Communion time again, and members of the Dietz family are in a serious, reverent mood—except, of course, the boys. From left to right are (first row) John; (second row) Delores, Elaine, and Jimmy. The mom is also Elaine. The photograph was snapped at Conkling Street and Fait Avenue in 1961. (Courtesy of Nancy Van Keuren.)

Jim Charvat Sr. (1910–1960) and his wife, Doris Smith Charvat (1918–2000), are lounging in Patterson Park in the 1940s. The Big Red Schoolhouse, or Patterson Park High School, is visible in the background. Charvat rose to the rank of chief petty officer in the Navy and then worked as a lithographer. (Courtesy of Jim Charvat Jr.)

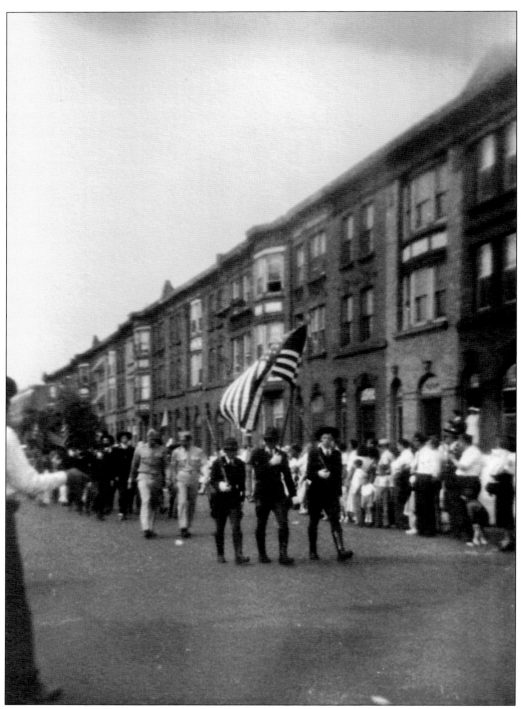

The I Am an American Day Parade passes along Linwood Avenue in the late 1940s, and the residents of Highlandtown are on their feet out of respect for the Stars and Stripes passing by. (Courtesy of Don Ulsch.)

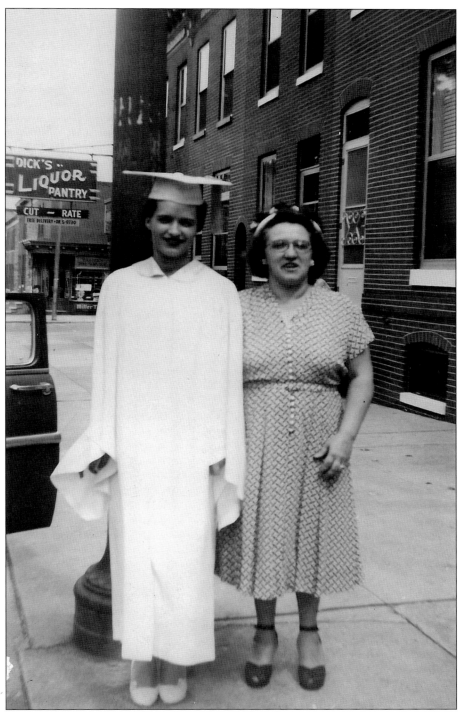

Florence Kielczewski and her mom take time for a photograph along Eastern Avenue on the occasion of her graduation from Catholic High School in the early 1950s. Dick's Liquor Pantry and Eastern Tire Service are visible in the background. (Courtesy of Florence Sdanowich.)

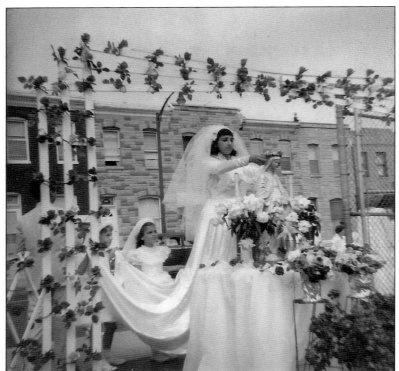

It is May, and the crowning of the Blessed Mother is taking place outside Our Lady of Pompei Church. The young lady placing the crown on Mary's head is unidentified. The photograph is from around 1964. (Courtesy of Mary Moscato Chaikin.)

No Highlandtown photo album is complete without baby pictures in Patterson Park. In this April 1953 image, Margaret Olencz is the mom, and daughter Nancy is the baby. (Courtesy of Nancy Van Keuren.)

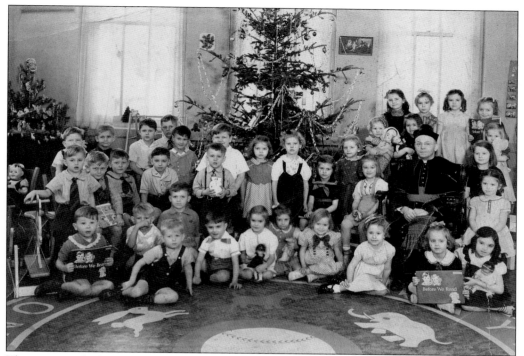

This picture, which is also on the cover, was taken in December 1941. It depicts the first kindergarten students to attend Holy Rosary School on South Chester Street. Florence Sdanowich is visible behind and just to the left of Father Wachoviak. (Courtesy of Florence Sdanowich.)

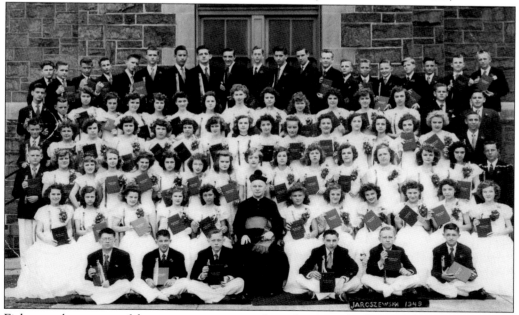

Eight years later, many of the same youngsters posed together again for their eighth-grade graduation, and so did Father Wachoviak. Holy Rosary School refers to itself today as "Baltimore's Premier Polish American Roman Catholic church." (Courtesy of Florence Sdanowich.)

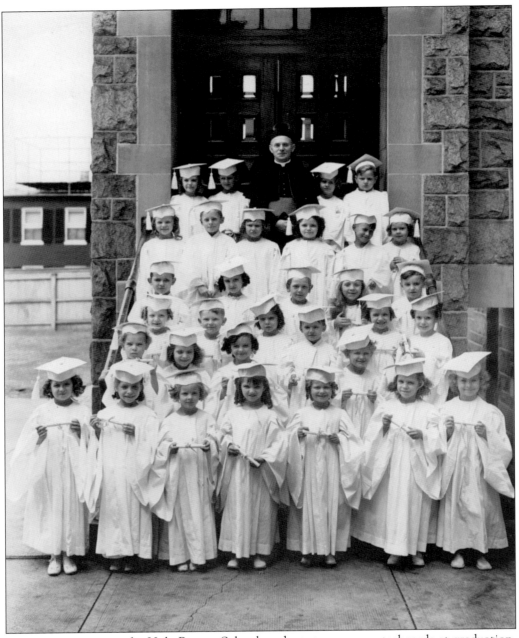

It was quite common for Holy Rosary School students to wear mortarboards at graduation. Commencement day for this kindergarten class took place in 1942, complete with caps, gowns, and diplomas. (Courtesy of Florence Sdanowich.)

The archbishop of Baltimore, William Henry Cardinal Keeler (left), is greeted by Joseph Zannino (right) in this photograph taken at Our Lady of Pompei. A native of San Antonio, Texas, Cardinal Keeler retired in 2007. Rev. Luigi Petti, of Our Lady of Pompei, is at the center in this undated photograph. (Courtesy of Felicia Zannino-Baker.)

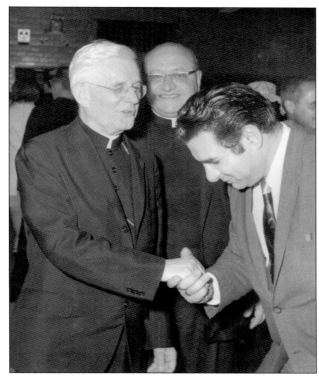

With the old Sacred Heart of Jesus School in the background, a photographer snapped this image of the church's Diamond Jubilee celebration moving to the school yard in 1948. Sacred Heart is on the site of Fort Marshall, which stood atop the highest point in Highlandtown. (Courtesy of Don Ulsch.)

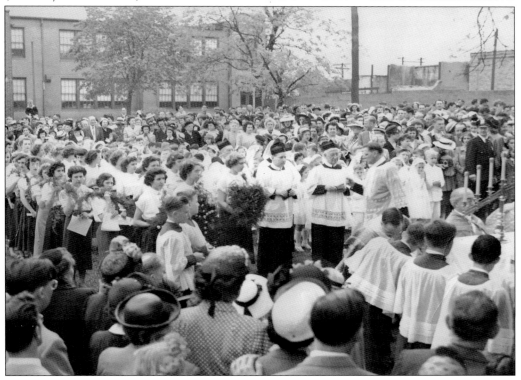

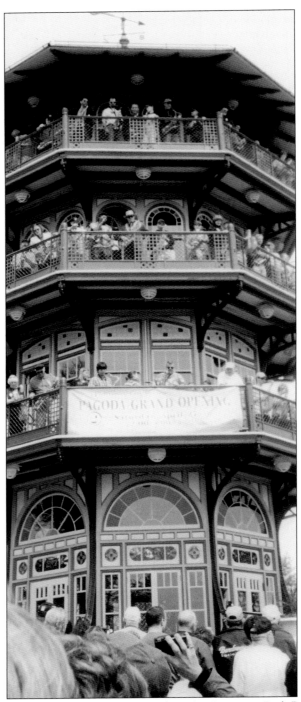

About 100 saxophones were strategically stationed on the Patterson Park Pagoda in celebration of the observation tower's grand reopening on April 27, 2002. Vandalized, laden with layers of toxic lead paint, and closed to the public for more than a decade, the restoration cost over half a million dollars. (Courtesy of Florence Sdanowich.)

Waving a flag, one-year-old Elfreda Dollenger is all smiles (sans teeth) in the backyard of the family home at 202 South Clinton Street in the summer of 1919. (Courtesy of John Meisenhalder.)

Block parties kept morale up on the home front during World War II. On a summer day in 1943, the residents of the 300 block of South Robinson Street were getting ready for their block party, complete with a stage at the corner of Bank Street. (Courtesy of Cecilia Trentowski.)

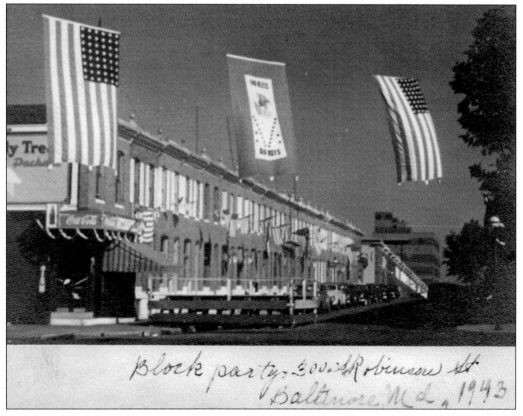

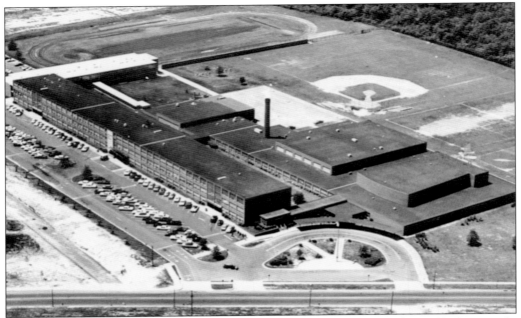

The new Patterson High School on Kane Street is seen from the air in this 1969 photograph. In addition to high school games, the Eastwood Pony League played most of its baseball games on Patterson's diamond at the upper right. The Patterson Clippers' football and soccer fields are visible to both sides of the baseball diamond. (Courtesy of Ed Dobbins.)

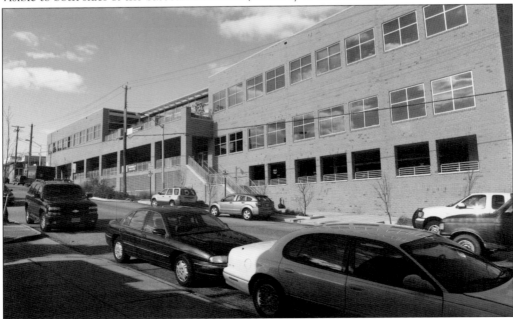

The Highlandtown Healthy Living Center—one of six such centers in the city—is operated by Baltimore Medical Services. In total, more than 125 community health care centers are located in Maryland. The attractive building, a sign of Highlandtown's renewal, is on the former site of a parking lot on Fleet Street between Dean and Eaton Streets. (Author's.)

Your

School Ring

WILL KEEP PLEASANT

MEMORIES ALIVE FOREVER

PAY 50c A WEEK

S. & N. Katz

105-113 N. CHARLES STREET

Tradition has high school students receiving their class rings during their junior year. Local jeweler S&N Katz had a location on Eastern Avenue at Conkling Street and offered students 50¢-a-week financing in this advertisement, which appeared in the 1938–1939 Patterson Park High School yearbook, the *Clipper*. (Courtesy of Cecilia Trentowski.)

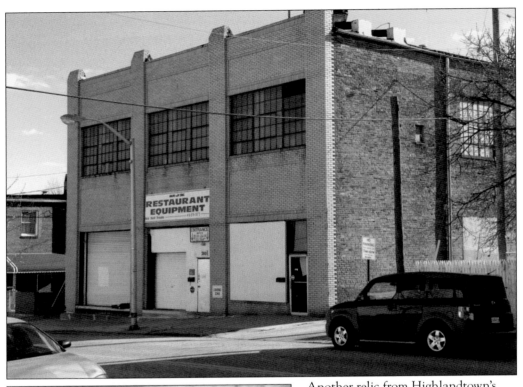

Another relic from Highlandtown's past is this building at 3801 Fleet Street. When it opened in 1936, it was New Highland Lanes, with 15 duckpin bowling alleys on each of its two floors. The owner, Jimmie Marks, died in 1956, and the bowling center closed during the 1960s. (Author's.)

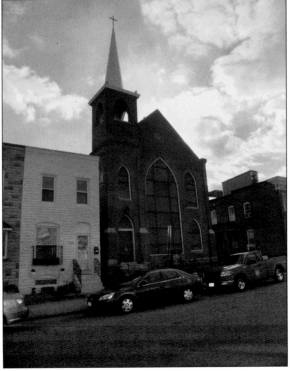

Nestled into the 3400 block of Gough Street is Salem United Methodist Church. Reaching out to neighborhood youngsters, the church offered "Galactic Blast" vacation Bible school during the summer of 2010. (Author's.)

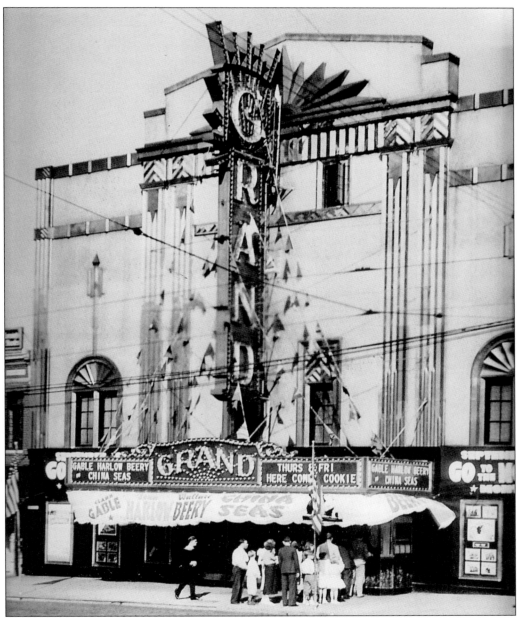

The Grand Theater opened as a vaudeville house in 1914, although some sources say 1911. It seated more than 1,400 people. When this 1935 shot was taken around Labor Day, the movie *China Seas*—starring Clark Gable, Jean Harlow, and Wallace Beery—was playing. (Courtesy of the Creative Alliance at the Patterson.)

The relic in this photograph is the old Sacred Heart School, not Joe Ulsch, who was an active member of the parish. The photograph was taken in the late 1920s. Ulsch (1912–2009) would later be a detective sergeant with the Baltimore City Police Department. (Courtesy of Don Ulsch.)

It is April 1937, and Frances Smith has climbed up a tree in front of the Patterson Park Conservatory. Built in 1876, the conservatory fell into disrepair and was demolished in 1948. (Courtesy of Jim Charvat Jr.)

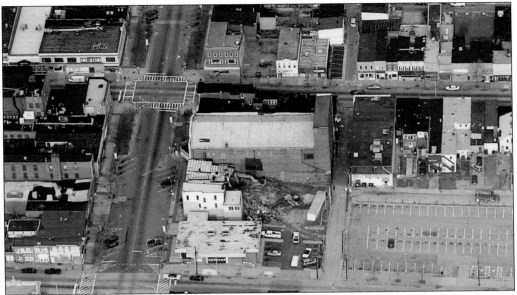

Those who supported demolition of the Grand claimed its roof was beyond repair. Yet, this aerial photograph from January 2004 seems to suggest otherwise. The high back wall of the theater was called the fly tower to accommodate lights, backdrops, and scenery used in live performances. (Courtesy of Ed Dobbins.)

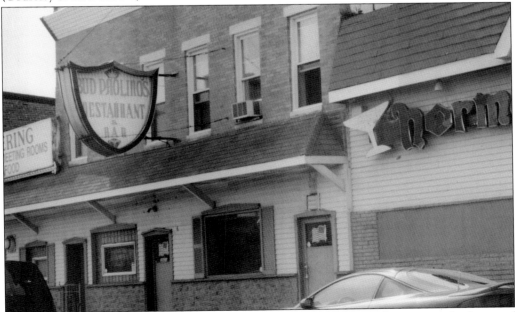

Bud Paolino's, located at 3919 East Lombard Street, was a favorite destination for lovers of Chesapeake Bay steamed crabs. From Joe Six-Pack to Joe DiMaggio, the restaurant and bar were Baltimore landmarks from 1946 until 1991. After converting the original restaurant to Normandy Hall for event catering, Bud relocated the eatery around the corner and renamed it Enrico's, in honor of his grandfather. August "Bud" Paolino died in 2004 at age 80, and Enrico's has since closed. (Courtesy of Tiffany Bock.)

The Knights of Columbus Santa Maria Chapter Hall at Fleet Street and Highland Avenue was built by E. Eyring & Sons Company, a general contracting and engineering firm headquartered in Highlandtown and dating back to 1887. Eyring was also responsible for the construction of the Patterson Theater in 1930, Our Lady of Fatima Church, and numerous other buildings throughout Baltimore. In recent years, the Knights of Columbus Santa Maria Chapter Hall has been converted into condominiums. (Courtesy of Tiffany Bock.)

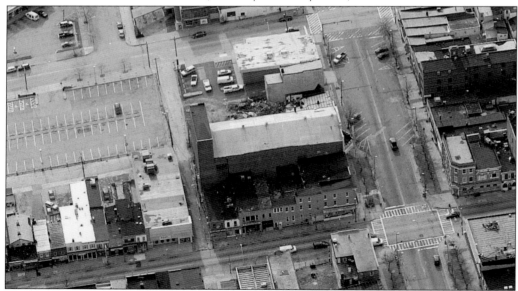

Looking down at the intersections of Eastern Avenue and Dean Street (left), as well as Conkling Street (right), is one last look at an intact Grand Theater, plus the buildings fronting Eastern Avenue that will come down in early 2004 for the new library. The convenience store in the upper left corner on Fleet Street was the original 1917 site of Schaefer & Strominger, a now defunct Maryland automobile retailer that once owned dealerships from Bel Air to Salisbury. (Courtesy of Ed Dobbins.)

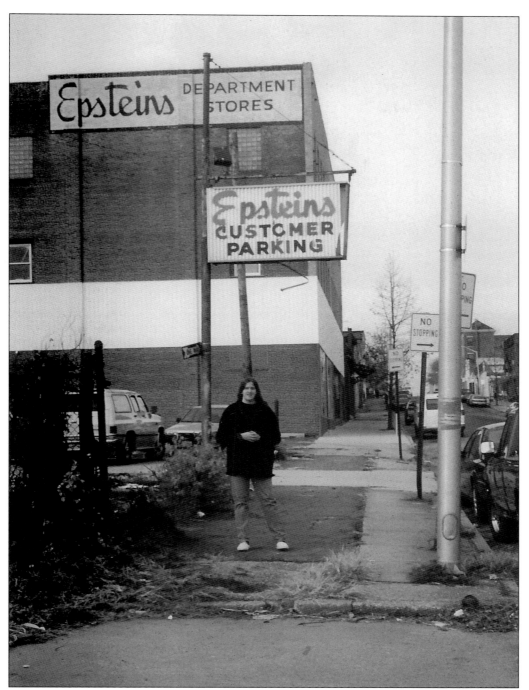

Jacob Epstein, a 17-year-old Lithuanian immigrant, opened the Baltimore Bargain House in 1882. His business quickly expanded to mail-order, wholesale, and clothing manufacturing. Ultimately, it would evolve into the Epstein's Department Store chain. The Highlandtown location was one of its most popular. Tiffany Bock is shown in this 1990s photograph near the Bank Street entrance. (Courtesy of Tiffany Bock.)

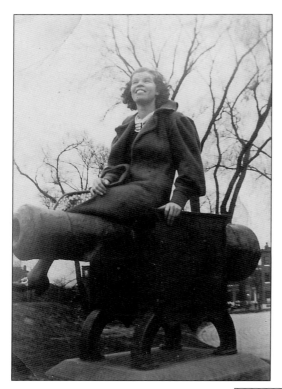

Frances Smith has come out of her tree at Patterson Park and found a comfortable seat atop a cannon on Hampstead Hill in this April 1937 shot. A plaque mounted on it pays tribute to Rodgers's Bastion, which included some 100 cannons and 20,000 troops that were ready to defend Baltimore from the British on September 12, 1814. The British wisely decided to go home. (Courtesy of Jim Charvat Jr.)

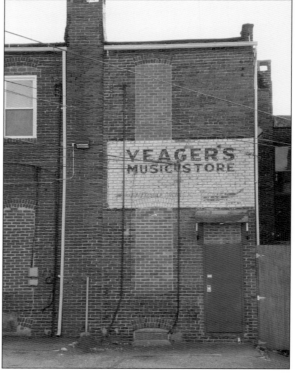

Yeager's Music Store, which was found at Eastern Avenue and Clinton Street, was a favorite haunt of Arthur Godfrey, also known as "Old Redhead," when he worked for WFBR in the 1930s. During the 1970s, Yeager's opened additional stores in other areas of Baltimore. The decision was an economic disaster, and Yeager's ultimately closed. The Highlandtown flagship location is now a convenience store, but this relic remains on the back of the building. (Author's.)

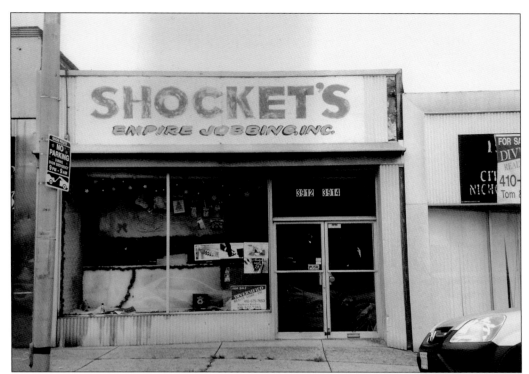

Shocket's at 3912 Eastern Avenue was Highlandtown's premier bargain outlet. Owned and operated by Nick D'Adamo Sr. and his son Nick Jr., Shocket's was the place for tube socks, underwear, holiday decorations, and the like and was generally accepted as the cheapest store in Baltimore. (Courtesy of Tiffany Bock.)

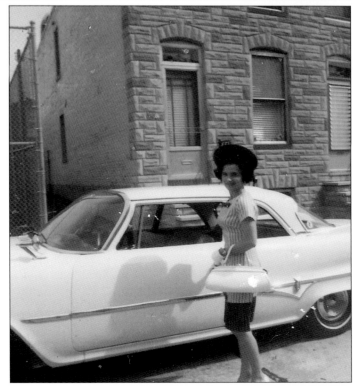

There are many relics, such as the hat, purse, and car, in this photograph that date it. It was the era of the "lead sled," with the exaggerated tail fins of Chrysler products leading the way. Florence Sdanowich is ready to get behind the wheel of her 1960 Dodge Dart in this shot from Mother's Day in the early 1960s. (Courtesy of Florence Sdanowich.)

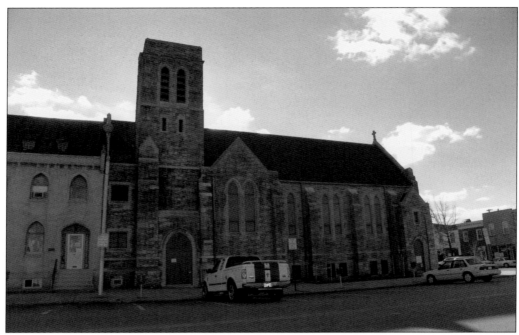

Nazareth Lutheran Church, 3401 Bank Street, also operates Nazareth House, a safe house for men recovering from alcohol or drug addiction, located just a few doors away. Nazareth Lutheran Church is a parish of the Missouri Synod and has been around for more than 100 years. (Author's.)

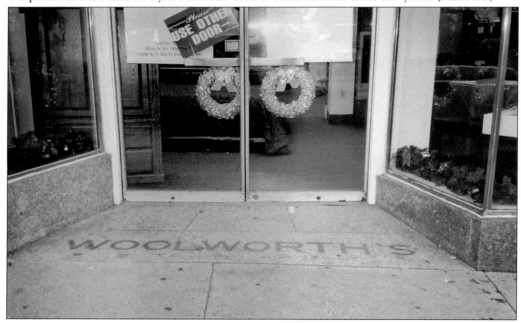

It says Rent-A-Center on the door, but longtime residents remember 3504 Eastern Avenue as F.W. Woolworth's, or the five-and-dime." Anyone requiring proof need only look down at the sidewalk as they enter. A Kresge's store once existed next door and was a favorite destination for kids looking for toys. (Courtesy of Tiffany Bock.)

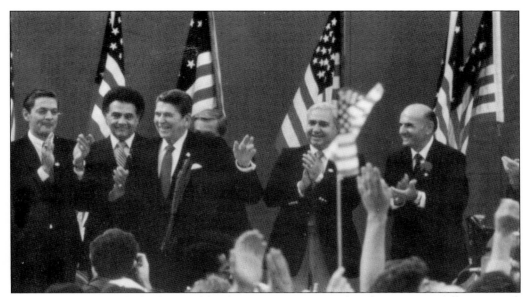

If there was ever any doubt that Highlandtown restaurateur Bud Paolino was not well connected, it was dashed when this photograph was taken on October 8, 1984. That is Pres. Ronald Reagan, third from the left, with Bud applauding (second from the right) at the dedication of the Christopher Columbus statue in Baltimore. The other men are unidentified. (Courtesy of Jim Baker.)

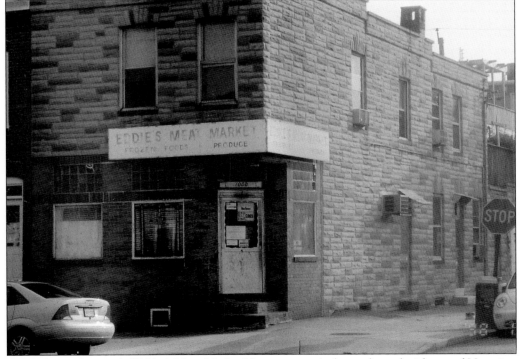

A faded sign that reads "Eddie's Meat Market" hangs over windows adorned with rusted Venetian blinds at the corner of South Clinton and Dillon Streets. Sadly, most corner grocers of Highlandtown's past have since disappeared, but Eddie's survives surprisingly. (Courtesy of Tiffany Bock.)

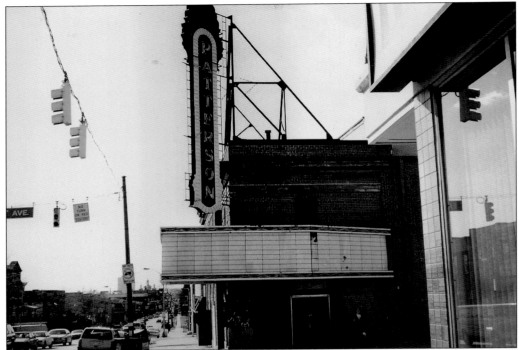

Highlandtown's last movie house, the once iconic Patterson Theater, gave up the ghost and shut its doors in 1995. The original Patterson opened in 1910 as a theater and dance hall located at Eastern and East Avenues. Razed in 1929, it was replaced by this structure the following year on the same site. Spared the wrecking ball, it is now home to the Creative Alliance, a coalition of artists and supporters. It houses art galleries, a classroom, offices, a media lab, a 180-seat performance theater, and eight apartment studio suites. (Courtesy of Tiffany Bock.)

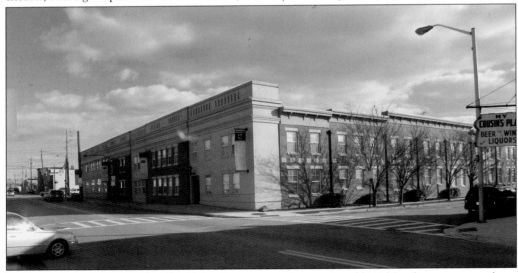

In a most impressive example of building restoration and reuse, the old Highlandtown streetcar barn has been converted into senior housing. Occupying an entire square block at Lombard, Grundy, Pratt, and Haven Streets, rent for a one-bedroom apartment starts at $515 a month. (Author's.)

114

It once produced National Bohemian, Bock, and Premium beers, as well as Colt 45 Malt Liquor, but as this 1990s photograph shows, the buildings formerly belonging to the National Brewing Company are being converted to homes and offices. "Mr. Boh," National's one-eyed, moustached trademark, is now depicted in a large red neon sign atop the old brewery and is visible for miles. (Courtesy of Tiffany Bock.)

A skating rink and bingo hall once occupied this spot on Fleet Street between Highland Avenue and Conkling Street. Today, three-story townhouses afford residents an impressive view of downtown Baltimore to the west from one of the highest points in Highlandtown. (Author's.)

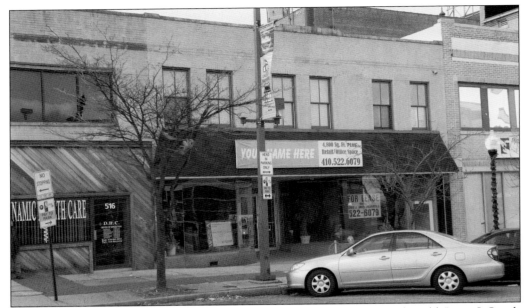

Long before the big box companies arrived, specialty stores ruled the retail world. Louis J. Smith Sporting Goods occupied this space in the 500 block of South Conkling Street for decades. During the 1940s, singing cowboy Roy Rogers, who was appearing across the street at the old Grand Theater, reportedly bought, with no money down, a motorcycle here when they were part of the store's inventory. (Author's.)

Some of Highlandtown's relics require a little searching to find. Here, on the backs of these buildings in the 3800 block of Eastern Avenue can be found remnants of former tenants Irvin's Department Store and Read's Drugstore. The Read's located here was one of two Read's found on the Avenue. (Author's.)

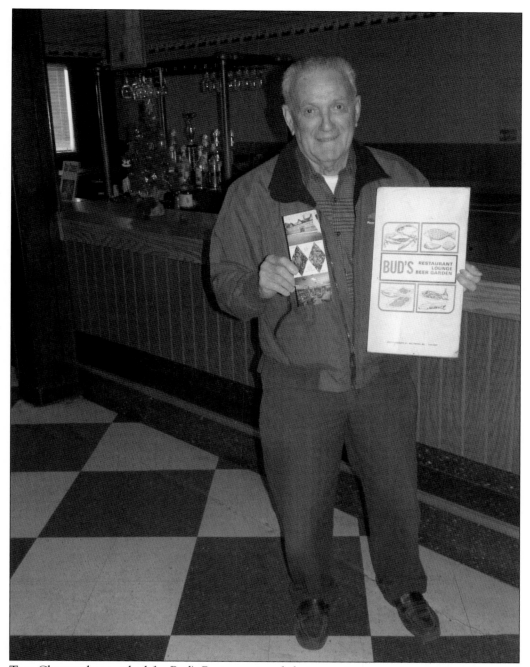

Tom Charvat has worked for Bud's Restaurant and their catering operations, Tiffany East and the Normandy Room, for five decades. The unofficial historian of Bud's, he confesses to being a pack rat. Here, in Bud's once bustling barroom, he shows off an old postcard and menu. The former restaurant is now part of the Normandy Room catering facility. (Author's.)

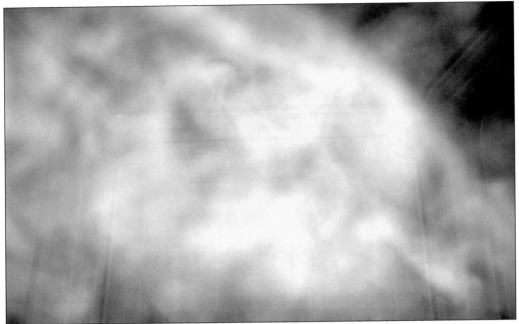

Was the Grand Theater haunted? Many former employees and patrons believed so. The day before demolition began, Ed Dobbins entered the old movie house through a large hole in the south wall. He took random photographs of the stage, ceiling, and auditorium. When the photographs were processed, some interesting and unsettling smokelike images appeared on several, including what looks like a man's face in the center of the photograph above and a severed arm in the lower right-hand corner of the shot below. (Both, courtesy of Ed Dobbins.)

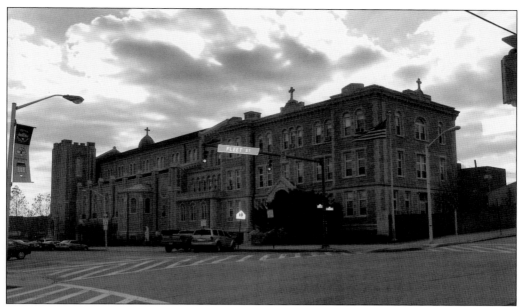

Built in 1908, Sacred Heart of Jesus Church boasts beautiful architecture and remains a strong influence in the community. Occupying a square block, it is bounded by Fleet Street to the north, Foster Avenue to the south, Highland Avenue on the west, and Conkling Street to the east. Military outpost Fort Marshall once occupied the site. The original parish, built in 1873, was on the corner of Highland and Foster Avenues. (Author's.)

The alleys of Highlandtown are narrow, reflecting the size of vehicles in the early 20th century. Modern-day vehicles, like fire engines and garbage trucks, find the dimensions challenging at best. This one is in the unit block of South Luzerne Avenue. (Courtesy of Tiffany Bock.)

Other examples of new housing in Highlandtown are these three- and four-story units in the 400 block of South Grundy Street. Across the street, a new Walgreens occupies the former site of Goldenberg's. (Author's.)

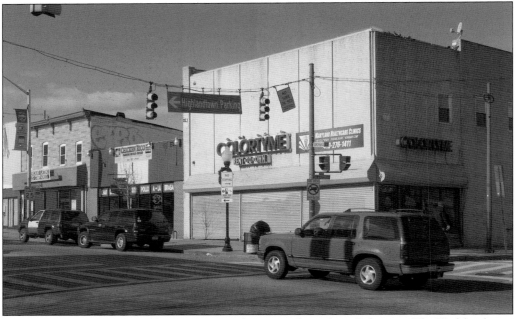

The chain Princess Shops sold women's apparel in stores throughout Baltimore. The Highlandtown location at Eastern Avenue and Eaton Street opened in the 1960s. Kramer's candy shop was next door. In time, Princess Shops added men's wear, calling this division King's Court. This building is occupied today by a rent-to-own business. (Author's.)

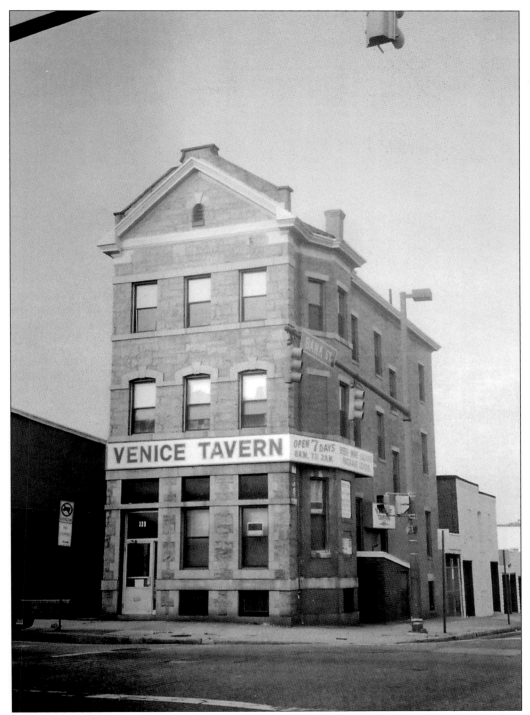

The uniquely shaped building that the Venice Tavern is located in appears somewhat odd, standing on its own at the corner of Conkling and Bank Streets. Maryland real estate records say it was constructed in 1920, however, it is believed to be older. (Courtesy of Tiffany Bock.)

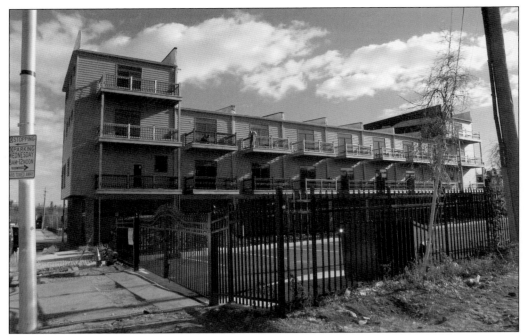

This rear view of the new housing units in the 400 block of South Grundy Street reveals garages and a gated parking lot. Parking spaces in Highlandtown have always been a valuable commodity. (Author's.)

Local photographer Ronald Pellegrini captured this image of (left to right) Annabelle and Bud Paolino, Baltimore mayor Clarence "Du" Burns, and Councilman Dominic "Mimi" DiPietro at Tiffany East's catering hall at 4116 East Lombard Street around 1988. The Paolinos opened Tiffany East in 1980. Today, their grandson Jim Baker operates it. (Courtesy of Jim Baker.)

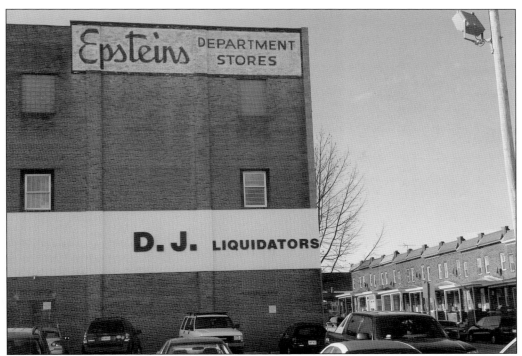

Here is more evidence on Bank Street of Highlandtown's retailing past. Epstein's Department Store had two buildings: one on Eastern Avenue and the other, shown here, on Bank Street. D.J. Liquidators occupies the Bank Street space today. (Author's.)

Haussner's Restaurant, located at Eastern Avenue and Clinton Street, was internationally known and one of the most popular eateries in Baltimore, seating as many as 2,000 patrons a night. After the restaurant closed in 1999, a steak house opened, but it quickly failed. Baltimore International College, a culinary school, owns the building and has considered converting it into a parking garage. Meanwhile, inlaid panels on its exterior remind passersby of what used to be. (Author's.)

From left to right, Elsie May, Thelma, and Elfreda Dollenger pause during backyard playtime for this photograph taken in 1930. The Dollengers called 202 South Clinton Street home. In the background at the upper right, a neighbor child gazes over the wall from the yard next door. (Courtesy of John Meisenhalder.)

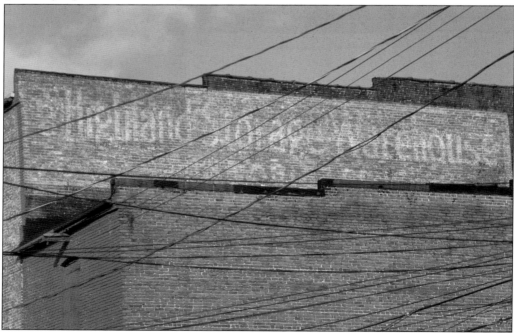

Barely visible on the brick wall of this building in Highlandtown on Highland Avenue and Bank Street are the words "Highland Storage Warehouse." This is where the von Paris moving and storage business was based for many years before outgrowing the site. Founded in Highlandtown, the von Paris company also owns and operates Hampden Moving & Storage, another iconic Baltimore business. (Author's.)

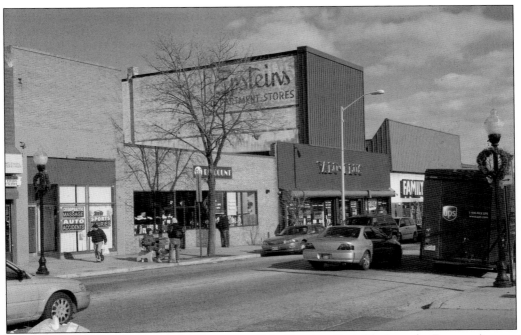

The former Epstein's Department Store, now a Valu-Plus, is still visible from the Eastern Avenue side. Epstein's was a must for most Highlandtown shoppers. Two decades after the local chain disappeared, it is still remembered fondly by longtime residents and shoppers. (Author's.)

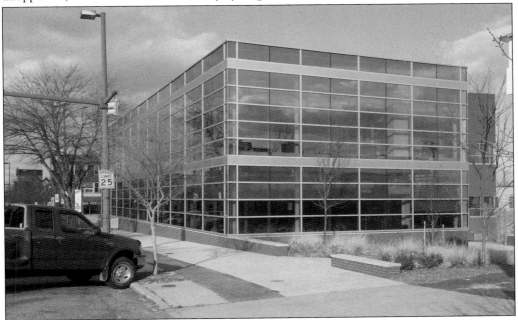

The Southeast Anchor branch of the Enoch Pratt Free Library now occupies the site of the former Grand Theater in the 500 block of South Conkling Street. In 2010, a huge crowd attended the dedication of the bust of musician Frank Zappa at the library's northwest entrance. Zappa was born in Baltimore in 1940. (Author's.)

Globe Brewing Company was another local brewer, producing Arrow 77 beer. Along with local suds from National, Gunther, and American breweries, Arrow 77 competed for the palates of Baltimoreans for decades. With the slogan, "It hits the spot," Arrow 77 is being pitched to the camera by four-year-old Shelley Doroff. This photograph was taken on South Ellwood Avenue during the holiday season of 1960. (Courtesy of Shelley Sealover.)

A solitary cat gazes through a torn screen in the window of a home in the 400 block of South Eaton Street. If those formstone walls could talk, they would have more than a century of stories to tell. And if they are fortunate enough to have as many lives as that cat supposedly does, these walls, and all of Highlandtown, will be around for a long time to come. (Author's.)